IMAGES
of America

OLMSTED'S
LINEAR PARK

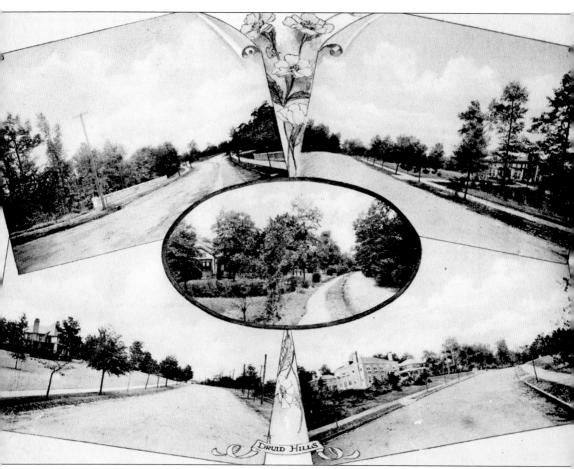

A HISTORIC MONTAGE: This montage of historic images captures street scenes in Druid Hills between 1910 and 1920. At upper left is a view looking west across the bridge into Oak Grove Park. (Atlanta History Center.)

OLMSTED'S SUGGESTED TROLLEY: This is the electric trolley envisioned by Joel Hurt and planned by Frederick Law Olmsted Sr. in the planted verge of Springdale Park. Olmsted suggested the park as the location for the trolley as a more efficient and safer option than the typical streetcar. (Atlanta History Center.)

IMAGES
of America

OLMSTED'S
LINEAR PARK

Jennifer J. Richardson and Spencer Tunnell II
Foreword by Mark C. McDonald

ARCADIA
PUBLISHING

Published by Arcadia Publishing
Charleston, South Carolina

Printed in the United States of America

Library of Congress Control Number: 2022930635

For all general information, please contact Arcadia Publishing:
Telephone 843-853-2070
Fax 843-853-0044
E-mail sales@arcadiapublishing.com
For customer service and orders:
Toll-Free 1-888-313-2665

Visit us on the Internet at www.arcadiapublishing.com

In honor of Tally Sweat, who made the dream of a renovated park come true. In honor of Alida Silverman, who, with help from others, established preservation and landmark districts in Druid Hills. In memory of Sally Harbaugh, who made Olmsted a hallowed name in Druid Hills. Tally and Sally's legacy can be seen and enjoyed by anyone passing by the historic linear park.

In memory of Lisa Martin Tunnell, who left us too soon. She was the backbone of support for Spencer in all his endeavors and the person who brought out the best of his talent, vision, creativity, and artistic nature—which leaves a legacy for each of us.

CONTENTS

Acknowledgments 6

Foreword 7

Introduction 8

1. A Brief Biography of Frederick Law Olmsted Sr. 11

2. Joel Hurt, Businessman and Builder of Atlanta 21

3. Hurt, Olmsted, and the Druid Hills Corporation 29

4. Olmsted's Design for the Park, Lots, and Roads 41

5. Intrusions and Threats to Olmsted's Plan 55

6. Rehabilitation and Renovation of the Park 73

7. A Walking Tour of the Neighborhood 83

8. Epilogue 119

ACKNOWLEDGMENTS

The authors thank the Olmsted Linear Park Alliance (OLPA); its boards of directors and executive directors through the years, especially George Ickes, Sandy Kruger, and capital projects chair Brian Bowen; as well as OLPA's many supporters. We thank the other alliance members including the Atlanta and DeKalb County parks departments, Fernbank Inc., and DeKalb County commissioner Jeff Rader. We appreciate the help of Georgia Power, in it from the days of Joel Hurt himself. We acknowledge those within the Georgia Department of Transportation (GDOT) who were aligned with our values and supportive of our goals.

We thank the National Association for Olmsted Parks, the Rose Library at Emory University, the Atlanta History Center, the Druid Hills and Lullwater Garden Clubs, the DeKalb County History Center, The Bremen Museum of Jewish History, and all those who provided photographs and research for our project, including Meredith Conklin and Rebecca Newton. Additionally, we thank Staci Catron of the Cherokee Garden Library of the Atlanta History Center for her support and encouragement. For a project that has been ongoing since 1998, Spencer wants to acknowledge the assistance of both current Tunnell & Tunnell Landscape Architecture staff Matt Sussman and Erik Belgum, and former staff for their contributions and forbearance through the many years toiling in this particular vineyard.

We acknowledge Patricia O'Donnell and Peter Viteretto of Heritage Landscapes LLC, landscape architect of record for Phase I; along with the assistance of Bruce Pinkney and Arnie Silverman; Heery International; Kimley-Horn; Pharr Engineering; Charles Beveridge PhD, at the ready to slog through Deepdene during a tropical storm or wander from Springdale to Dellwood in the golden hours of May; Alida Silverman, always indefatigably supportive; Tally Sweat, so often the glue that kept it all moving forward; Sally Harbaugh, who remains the guiding light to which we return; and lastly, Jessica Busby—this is her book as much as it is ours.

Unless otherwise noted, all images are from the authors' collections. Images from the Olmsted Archives are credited as NPS Olmsted; these are published here courtesy of the US Department of the Interior, National Park Service, Frederick Law Olmsted National Historic Site. Material drawn from the Library of Congress is credited as LOC, the Kenan Research Center at the Atlanta History Center as AHC, and photographer Emily Followill as Followill.

FOREWORD

Two of Georgia's highest achievements in the field of architecture are not buildings, they are works of landscape architecture. The first is Gen. James Oglethorpe's plan for the colonial city of Savannah. The other is Frederick Law Olmsted Sr.'s creation of the linear park in Druid Hills in the city of Atlanta. This masterpiece is composed of five connected pastoral parks parallel to Ponce de Leon Avenue and the picturesque Deepdene Park, a 22-acre hardwood forest with stream banks, bridges, and dramatic contours. The genius of Olmsted's design is that although these parks are intricately designed, they give the appearance of being natural and provide a bucolic setting for Joel Hurt's early subdivision.

It would seem that the connection to America's premier landscape architect was somehow forgotten, for like many Atlanta landmarks, the Olmsted Linear Park was threatened with destruction beginning in the 1960s. The Georgia Department of Transportation developed a plan to connect downtown Atlanta and Stone Mountain with a freeway; had it been implemented, it would have destroyed Deepdene Park, as well as Dellwood and Shadyside Park, and adversely affected the fine residential architecture of Druid Hills. Fortunately, federal transportation laws, neighborhood activists, and a plethora of Atlanta attorneys had something to say about this ill-conceived plan, and it was halted.

The Olmsted Linear Park has now been beautifully rehabilitated and is greatly appreciated by neighbors and visitors alike and protected and managed by the Olmsted Linear Park Alliance. This effort received the Georgia Trust for Historic Preservation's highest award, the Marguerite Williams Award, in 2012. This fine volume by noted landscape architect Spencer Tunnell and historian and neighborhood activist Jennifer Richardson documents the history of the park, its development, its threatened destruction, the fight to save it, and the drive to rehabilitate it for future generations. This volume will go far in ensuring that the Olmsted lineage of this national treasure, its salvation, and its beautiful restoration will never be taken for granted nor forgotten.

—Mark C. McDonald
President and CEO
The Georgia Trust for Historic Preservation

INTRODUCTION

After working as a surveyor with several railroads, Joel Hurt came to Atlanta to seek his fortune. He worked in insurance and banking and helped build skyscrapers and other buildings in downtown Atlanta. He then tried his hand at land development, using his new East Atlanta Land Company to purchase acreage on which to build Atlanta's first suburb, Inman Park. Inman Park was named in honor of Hurt's friend Samuel Inman. It was to be served by an electric trolley line, which was an ingenious plan. It meant that people who lived there had a quick way into town for their jobs and back home, and the trolley system made money on both trips. Though the overall plan for Inman Park was a good one, it ended up not being as successful as Hurt hoped. Many lots were sold to speculators, who did not build on the land but held the parcels for possible resale and profit. Other lots did not sell at all. Hurt had to release and sell some of the green space he had set aside for parks and open land, which made Inman Park denser and more developed than he had wished and with less of the "out in the country" feel that he desired. Nevertheless, Hurt decided to invest in another subdivision not too far from Inman Park. He hoped the new development would be the "ideal residential suburb" he longed to build.

Hurt's Kirkwood Land Company purchased 1,400 acres north and east of Inman Park for the new community. The choice of site had its disadvantages and its advantages. On the negative side, it was mostly over-farmed rural land that had little value. It was hilly and rolling, with several tributaries of Peavine Creek scattered throughout the parcel. Parts of the land still showed the scars of the Civil War even 30 years later when Hurt purchased it. Jack pines dotted the landscape, and most mature hardwoods had already died or been cut. Transportation to the new site was poor: no trolleys ran through the area. The land itself did not have a lot to recommend it. On the positive side, it was within three miles of downtown Atlanta and virtually undeveloped. It was a clean canvas on which to paint Hurt's grand plan of a place for Atlantans to live: close enough to town to get there without too much trouble, and far enough away to have the feel of open country and space. Earlier, an electric streetcar had been extended from downtown Atlanta to an amusement park called Ponce de Leon Springs, and it would be easy to extend the line farther into the new community. Ponce de Leon Springs Amusement Park was already a popular attraction for many Atlantans, who traveled there by horseback, carriage, or streetcar.

Ponce de Leon Springs Amusement Park was built on a site where railroad workers had found two springs in a grove of beech trees owned by John Armistead in the 1860s. The railroaders drank from the springs and boasted that one of them, which smelled of sulfur, guaranteed good health to anyone who drank the waters. Soon, Atlanta physician Dr. Henry L. Wilson capitalized on the spring water by bottling and selling it. He named the springs in honor of Juan Ponce de Leon's springs in Florida, which were said to have medicinal properties as well as guaranteeing longevity.

Rail magnates Richard and E.C. Peters decided to build an amusement park at the site of the springs to draw even more visitors. The park had a manmade lake, pavilions, a casino, a dance hall, walking and riding trails, and nonmotorized amusement rides. The Peterses extended the

trolley line out to the park to encourage more visitors. The road that went beside the entrance to Ponce de Leon Springs was called Ponce de Leon Avenue.

When Hurt began the Kirkwood land project, he arranged for Ponce de Leon Avenue to be extended through his development and added electric trolley lines and rails to serve the new community, which was just a short distance from the former termination point at Ponce de Leon Springs. Frederick Law Olmsted Sr. was already quite famous, and Hurt, with his love of botany and horticulture, admired Olmsted and wanted to work with him. So Hurt hired the landscape architect and his firm to lay out the main roads, lots, parks, and smaller roads in the area around Ponce de Leon Avenue. Olmsted came to Atlanta to view the land and began to design the project in 1892. He created a series of linear parks, five of which were pastoral in nature and one wooded or "picturesque," as the centerpiece for the new community. On maps, he labeled these areas as "Public Pleasure Grounds." The intent of the linear park was to be as if the lawns of the private homes extended across the streets to the park and beyond to the lawns across the next street, creating one sweeping vista of green. Like the lots, the parkland followed the natural topography of the land.

Hurt and the Olmsted firm worked together on the most minute aspects of the new community. A great many letters were exchanged discussing such issues as topography, grading, lot sizes, covenants, the minimum cost for the homes to be built, names for streams, parks, and streets, and specific plants and planting schemes to be employed on the new property—not just the house lots but in the park segments as well. Because of the importance of the plants, one of the first things built was a nursery to hold and care for the plants until they could be installed. Members of the Olmsted firm visited Atlanta to take photographs of the land and to sketch ideas that would later be transformed into detailed plans.

From the very beginning of the partnership between Olmsted and Hurt, the linear park, with its links of public pleasure grounds, was the centerpiece of the community. Hurt and financial advisors questioned why the parkland should be set aside as open space instead of being built upon. After all, selling houses on the space reserved for the park would mean greater revenues for the company. But the Olmsted firm argued that the open space would draw the wealthiest and most prominent Atlantans to build alongside the park. And they were correct. Atlanta's leading businessmen, from Coca Cola founder Asa Candler to Georgia Power president Preston Arkwright, and prominent physicians, business owners, factory owners, and lawyers all chose to build on Ponce de Leon Avenue facing the linear park. Their presence enticed others to acquire land on the side streets and build homes there. The linear park really was the draw that lured the socially and financially prominent to the new community.

Despite Hurt's hard work and his vision for the ideal residential suburb, the concept proved expensive. The rolling land and streets had to be graded by mules pulling drays—in fact, all work had to be done by hand, not machines. Infrastructure such as paved roads, water, sewer, and electric systems were costly to install. In addition, the United States experienced several panics—recessions or financial slowdowns—between 1890 and 1907. Hurt decided to sell his land, all improvements thereupon, and interests to Asa Candler and his partners in 1909. When they incorporated that year, Candler and the others renamed the company the Druid Hills Corporation after a name suggested by Olmsted Sr. The most prominent stockholders included Asa Candler, Preston Arkwright, and George and Forrest Adair of the Adair Realty Company. The Olmsted firm remained as the landscape architect for the property. Later, the plans were used by engineer O.F. Kauffmann to construct the new community.

Thus began the Druid Hills known today: rolling hills, curvilinear streets dictated by topography, large estate lots, houses sited in the perfect spot on their land, and the Olmsted Linear Park—a string of six public spaces that anchored the community and made it a desirable place in which to build a home, not only in 1909 when the first house was constructed, but in the 21st century as well, as the area continues to thrive.

Olmsted Sr. died before the project could be completed. Members of his firm implemented Olmsted's plans, including his son Frederick Law Olmsted Jr. and stepson John Charles Olmsted.

Druid Hills was the senior Olmsted's last commission and the only one in the Deep South. It was also the culmination of his many years of experience and became his most mature work as well.

What magic did Frederick Law Olmsted Sr. work in his landscape designs? Olmsted scholar Dr. Charles E. Beveridge has identified what he calls Olmsted's seven S's, which are paraphrased here:

SCENERY: Creation of designs that give an advanced sense of space.

SUITABILITY: Does the plan fit the site and topography and enhance the genius of place?

STYLE: Design in a specific style, such as pastoral or picturesque.

SUBORDINATION: All elements, features, and objects are smaller parts of the overall design.

SANITATION: Engineering and drainage construction that promotes the mental and physical health of users.

SEPARATION: Areas with different designs are separated by distance.

SERVICE: The design will meet fundamental psychological and emotional needs.

This is the story of the Olmsted Linear Park in Atlanta: how a brilliant landscape architect turned an ugly and worn-out parcel of land into a paradise. Today and for generations to come, one can walk in Olmsted's living work of art and refresh mind and body by just observing and existing in the world of space created by Olmsted. Even though barely three miles from bustling and teeming downtown Atlanta and a metro area that is one of the largest in the nation, a peace can be found in Olmsted's linear park that renews, revives, and focuses a world of vision, creativity, calm, and beauty that can be grasped by any human being. Come and visit.

One

A Brief Biography of Frederick Law Olmsted Sr.

Connecticut Yankee? Child of privilege? A man who took a while to "find himself?" The father of the profession of landscape architecture? Frederick Law Olmsted Sr. was all these things and more. Surveyor, farmer, writer, abolitionist, social reformer, and finally, landscape architect.

In England and on the Continent, others had come before whose careers look, at least circumstantially, similar to Olmsted's, but the breadth of impact of this man, born April 26, 1822, was substantially greater in the United States than that of Andre Le Nôtre, Lancelot Brown, Humphrey Repton, or Andrew Jackson Downing. Each and every one of these men had enormous impact, and it could be argued, but for their existence, there would have been no Olmsted. Certainly, Olmsted stands on the shoulders of these predecessors and, in the case of Downing, friend. But it was Olmsted, with his unique blend of the various pieces that made up his particular gumbo, who created a profession that was born as the country—and the world— emerged from the Agricultural Age into the Industrial Age. Olmsted was quite simply the right man at the right time with the right message.

A name known to every first-year student of landscape architecture and to Civil War historians as well, this idealistic man seems to captivate many who begin to unravel one aspect of his character and then pick up another and another and another. How a life lived nearly 200 years ago can have such impact today is remarkable, but as the United States grows in population density, Olmsted's contributions to the life of this nation grow in importance, as does his appreciation for the natural environment and the role it can play in creating a healthy urban populace.

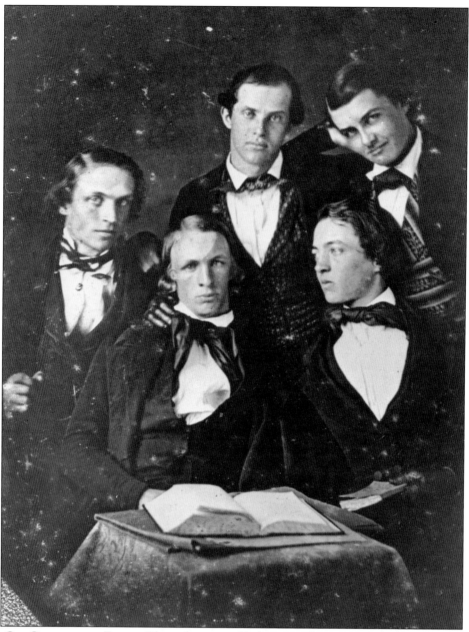

AN OLD CONNECTICUT FAMILY. Olmsted was raised by his somewhat remote father, his stepmother, and a series of parsons. He found solace in the woods of the countryside in a state still with a limited population. His studies were varied and eccentric by today's standards, though he fell in with a group of men while studying at Yale who would remain friends throughout much of his life. He explored adventure on the high seas, civil engineering, surveying, and farming, and it was this life on the land that grounded him and became the thread that would lead him to the future he sought. As he learned more, he became aware of how much he had yet to learn about caring for the land and sought out those who were aware of the most up-to-date scientific aspects of farming. Olmsted (lower right) and his brother John (top right) are pictured here with Charles Trask (far left), Charles Brace (second from left), and Frederick Kingsbury (center). (NPS Olmsted.)

19TH CENTURY INFLUENCER. Olmsted's first experiment in farming was on an uncle's farm in Cheshire, Connecticut. This and other experiments and research led to Olmsted's introduction to Andrew Jackson Downing, soon to be editor of *The Horticulturist*. Downing achieved acclaim in the 1840s with the publication of *The Architecture of Country Houses*. He designed gardens and landscapes in the mid-Atlantic region and New England and wrote several much loved—even revered—books on landscape gardening. Seven years Olmsted's senior, their association was to be a pivot point; *The Horticulturist* published some of Olmsted's first essays, and the connection with Downing led him further into scientific farming, somewhat akin to what would be called organic farming today. Olmsted's first farm of his own was at Sachem's Head, Connecticut, purchased with funds provided by his father. To further the exploration of farming, his father bought a larger property on Staten Island where Olmsted would delve deeper into what nurturing the land was all about. (Right, Sekkes Consultants.)

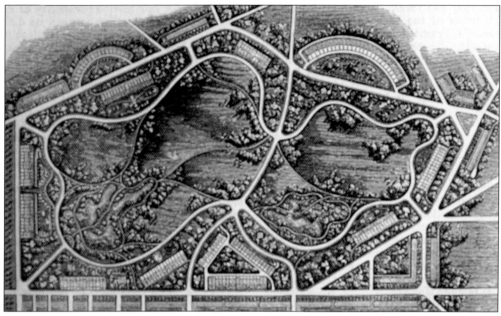

BIRKENHEAD PARK, LIVERPOOL, ENGLAND. Olmsted traveled to England to learn about new farming techniques. Upon arrival at Liverpool, he was told to cross the street and see what was being created at a new public park, Birkenhead. Parks had previously been royal or aristocratic properties open to a very specific component of the public. Downing urged Olmsted to write an article about Birkenhead Park and published it in *The Horticulturist*.

THE

COTTON KINGDOM:

A TRAVELLER'S OBSERVATIONS ON COTTON AND SLAVERY
IN THE AMERICAN SLAVE STATES.

BASED UPON THREE FORMER VOLUMES OF JOURNEYS AND INVESTIGATIONS
BY THE SAME AUTHOR.

BY

FREDERICK LAW OLMSTED.

IN TWO VOLUMES.

VOL. II.

NEW YORK:
PUBLISHED BY MASON BROTHERS,
5 and 7 MERCER STREET.
LONDON: SAMPSON LOW, SON & CO., 47 LUDGATE HILL.
1861.

OLMSTED'S TASTE FOR WRITING. Friend Charles Brace introduced Olmsted to the editor of the future *New York Times*, who engaged him to travel the American South and send back reports on the conditions there. With his farming background, belief in the Free Soil movement, and skill as a writer, Olmsted brought a necessary objectivity to his dispatches. The articles were published in 1856 in three volumes, including *The Cotton Kingdom*.

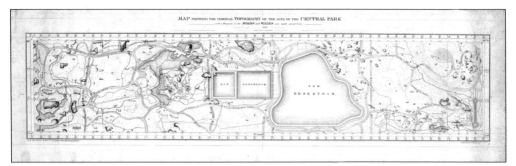

DOWNING HAD ANOTHER DREAM. Downing wondered why New York had no park the equal of Birkenhead, but his lobbying efforts were cut short by his tragic death at 36 in 1852. His death left a void in the growing landscape gardening movement he helped create and left behind a talented business partner, architect Calvert Vaux (below). A competition to design New York's new park materialized in 1857, and Olmsted was urged by friends to apply for the job of superintendent of the construction project. There was no design for the park and a good deal of political squabbling for this enormous public works project. Olmsted's travels in England, the writing career that he had pursued, and everything that had occurred for him in the prior 20 years gave him the varied experience to do the job. Once the superintendent, he had to be given permission to enter the competition for the park's design. Vaux and Olmsted joined forces, and a portion of their plan is pictured above. (Both, NPS Olmsted.)

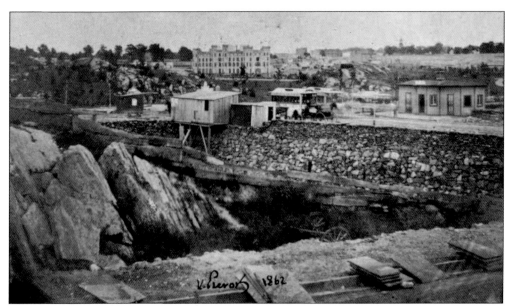

CONSTRUCTION ON THE PARK. Significant areas of the park were opened before the Civil War began. Construction continued during the war, but Olmsted clashed with commissioners and resigned in 1861 to become director of the US Sanitary Commission, where he helped assure that Union soldiers would receive proper care. Dysentery, typhoid, and no antibiotics were the facts of the day. In 1865, Olmsted returned to New York, where he and Vaux were able to complete work on Central Park. Olmsted had never managed more than seven laborers before construction was underway. The construction operations would consist of thousands of men and reshape a landscape that today is thought of as natural, though all of it was a product of the imagination of these talented individuals. Construction was not without controversy, as over 200 residents along the west side of the park in the Eighties were displaced by construction. Below, Vaux is third from the left and Olmsted is at far right. (Both, New York Public Library.)

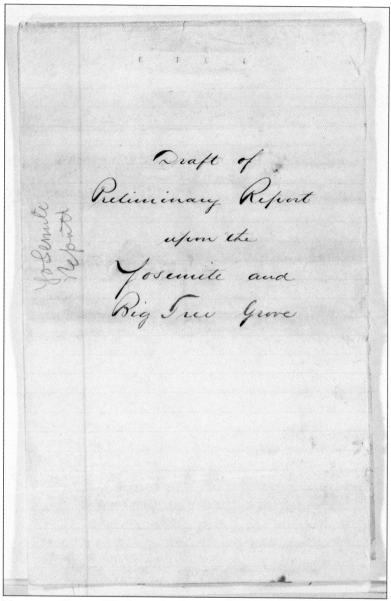

Draft of
Preliminary Report
upon the
Yosemite and
Big Tree Grove

OLMSTED NEEDED A BREAK. Work on the Sanitary Commission (which would become the Red Cross) was exhausting, and work on the park frustrating. Olmsted became the manager of the Mariposa Estate, an enormous gold mining complex in California, and his time there was important to him and to the nation. Travel to California was arduous and involved sailing to Panama, crossing the isthmus, and sailing north; a month was generally required. Olmsted arrived at Mariposa in October 1863. As manager, he became familiar with nearby Yosemite Valley. President Lincoln was instrumental in ceding Yosemite and the Mariposa Big Tree Grove to California, but Olmsted and his family were able to enjoy Yosemite as few European Americans had or would ever do again. His work in the area allowed him to crystallize his vision for the preservation of land of remarkable scenic and environmental quality. His report to the Yosemite Commission in 1865 outlines the ways in which vulnerable but important resources could be preserved for future generations. (LOC.)

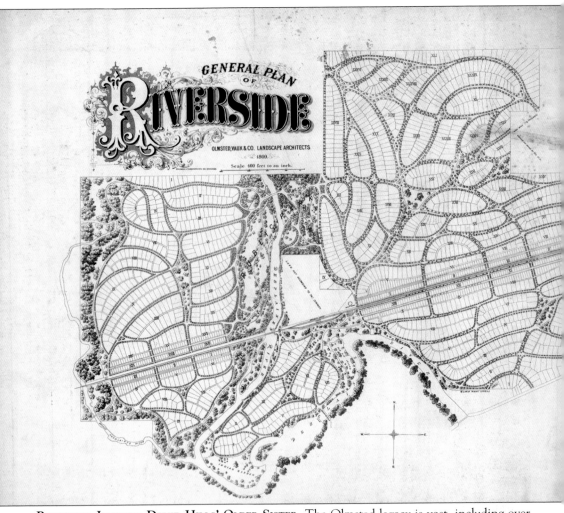

RIVERSIDE, ILLINOIS: DRUID HILLS' OLDER SISTER. The Olmsted legacy is vast, including over 20 large urban parks and park systems, the grounds of colleges, schools, and private estates, and residential communities such as Riverside—the firm's first planned suburban community from 1869. Similar in size to Druid Hills at about 1,400 acres, Riverside is about six miles outside of Chicago. Unlike Druid Hills, a railroad line formed the arrow-straight link to the city. A little over 20 years later, Olmsted urged Hurt to connect Atlanta and his Kirkwood Land Development project (Druid Hills) not by rail but by electric streetcar or trolley. The river/creek system inspired a series of parks that were implemented in Riverside but not in Druid Hills. Curvilinear roads in Druid Hills respond to the gentle undulations of the land; at Riverside, the curving roads provide a mystery uncommon on former prairie, where straight roads seem to lead to infinity. (NPS Olmsted.)

A Blended Family. In 1857, Olmsted's brother John Hull Olmsted died. In 1859, Frederick married John's widow, Mary, and adopted his brother's children, John Charles, Charlotte, and Owen. Frederick and Mary had two children of their own who survived infancy, Frederick Jr. ("Rick") and Marion. Rick (right) and John Charles (below) played major roles in the development of the business and the profession of landscape architecture, helping found the American Society of Landscape Architects in 1899. As the elder Olmsted grew ill, Rick became a partner in 1897. Eighteen years separated the half-brothers, and it was John Charles who became more involved in Druid Hills, making site visits in 1903. Marion was an artist and landscape architect, but her contributions to the firm are less well known. Some view the contributions of the talented successors to the firm as of less importance, but they took on the mantle left them by their astonishing father, creating a remarkable legacy of their own. (Both, NPS Olmsted.)

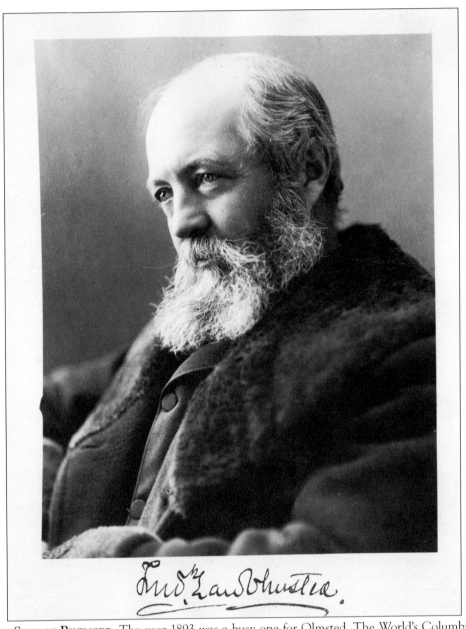

THE SAGE OF BILTMORE. The year 1893 was a busy one for Olmsted. The World's Columbian Exposition had opened in Chicago, and the world turned out to see the electrified "White City." Olmsted had been the glue that held the effort together and kept monumental egos at the planning table at bay. Biltmore House, for the grandchild of Commodore Vanderbilt, a Staten Island alumnus not unfamiliar to Olmsted, remains the largest private home built in the United States. A portion of the property would give birth to the US Forest Service. The first forester at Biltmore was Gifford Pinchot, a man hand-selected by Olmsted to help care for the forest Vanderbilt was urged to preserve and protect. Travel in those days was not easy, but Olmsted made the difficult trek from Biltmore to Atlanta. He believed that the South would recover from the Civil War and that the abundance of natural resources would lead to enormous growth in the region, and he wanted a foothold in that emerging world. (NPS Olmsted.)

Two

JOEL HURT, BUSINESSMAN AND BUILDER OF ATLANTA

Any large project needs different kinds of support in order to come to fruition. It needs a visionary with a dream; the means (either personal fortune or ability to acquire funds from others) to realize that dream; and specialized workers, artisans, other dreamers, and people who know how to get the deed done. Joel Hurt had already proved himself as a visionary by his multiple endeavors in Atlanta, including leading businesses such as his loan and insurance firms and building landmark skyscrapers. Though Inman Park did not turn out as successful as Hurt hoped, it was still a leap of faith into a new living situation for the Atlanta area: the suburb. Inman Park meant that residents no longer needed to live in the heart of the city—they could now purchase homes in a parklike setting with open space, open air, and a nearly rural environment even though only a mile or two from the city. Hurt was also well connected. He had money. He had married into the Woodruff family and had friends amongst the top social and business leaders of Atlanta. Hurt seemed the perfect candidate to dream of a Druid Hills to be perfected by the art of Frederick Law Olmsted Sr.

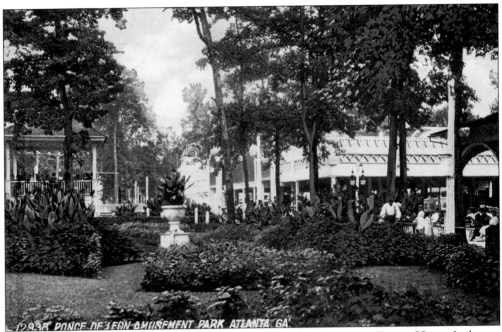

12,938 PONCE DE LEON AMUSEMENT PARK ATLANTA GA.

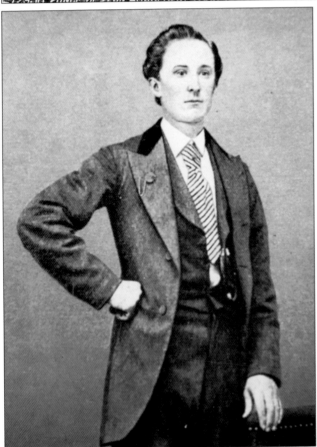

Buying Druid Hills. Joel Hurt (1850–1926) was the visionary behind Druid Hills. He bought land east of Ponce de Leon Springs Amusement Park. A savvy businessman, he knew the trolley line was already there, and it would be easy to extend the rail line into his property. This increased the likelihood of people riding the trolley into his new subdivision and perhaps buying a lot and building a home there.

A Young Joel Hurt. Trained as an engineer, Hurt began loaning money, constructing buildings, establishing street railway systems (trolleys), and building Atlanta's first suburb, Inman Park. His Kirkwood Land Company acquired 1,400 acres for his new project. He invited Frederick Law Olmsted Sr. to be a designer of the property, and his love of horticulture meshed well with Olmsted's.

RESIDENCES ON EDGEWOOD AVENUE.

HURT'S BIRTH, TRAINING, AND CAREER. Hurt started his career as a railroad surveyor. In 1875, he left the railroads and moved to Atlanta, where he formed the Atlanta Building and Loan Association, which he operated for over 30 years. In 1895, he founded the Trust Company of Georgia and served as its president. In 1886, he formed the East Atlanta Land Company, the developer of Inman Park, a community of Victorian houses. The same year, Hurt formed Atlanta's first consolidated streetcar or trolley company, the Atlanta & Edgewood Street Railway, to serve Inman Park. The historic Trolley Barn, which still stands, was where streetcars were stored. By 1891, Hurt had six trolley lines; he electrified them and merged them into one company, the Atlanta Consolidated Street Railway. (Both, AHC.)

JOEL HURT'S FAMILY. Joel Hurt married Annie Bright Woodruff (1855–1942), the sister of Atlanta entrepreneur Ernest Woodruff. Ernest lived in an Inman Park mansion and later acquired the Coca Cola Company. His son Robert ran it for decades. The Hurts had six children: George, Virgilee, Mabel, Eva Lou, Joel, and Sherwood.

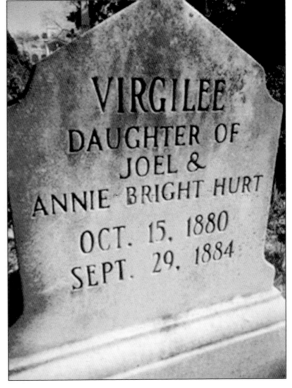

VIRGILEE HURT. Virgilee Hurt was diagnosed with a disease of the hip joint. Though the Hurts sought expert treatment for their daughter, Virgilee died one month before she turned four. She is buried in Oakland Cemetery with a simple tombstone. One of the linear park segments is named for her—the only one not named after a natural feature.

GETTING RICH. As Joel Hurt became wealthy, he moved from his small frame Hurt Cottage (which still stands) in Inman Park into a brick mansion on Elizabeth Street, also in Inman Park. One of Hurt's close neighbors, living at Callan Castle, was Coca Cola president Asa G. Candler and his family. At that time, Candler owned the Coca Cola Company and was one of the wealthiest men in Atlanta.

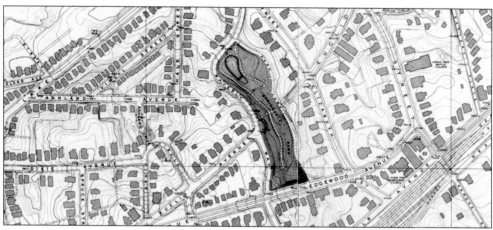

SPRINGVALE PARK. In 1895, Hurt began an interest in underground mining and bought and mined several sites in North Georgia. In 1889, Hurt used his money from the mining operation to build Springvale. Hurt donated land for a pet project: Springvale Park—the centerpiece of Inman Park. The park contained a lake and was beautified by plantings, many selected by Hurt himself. He was said to be the first to introduce live oaks into planting schemes in Atlanta.

SKYSCRAPERS. In 1891, Hurt constructed the Equitable Building in downtown Atlanta, which stood until 1971. The Equitable, also known as the Trust Company, was Atlanta's first skyscraper and stood eight stories tall. It was designed by Burnham and Root in a triangular shape to fit the land available. It is significant in that it was the first steel-framed skyscraper in Atlanta. Just 27 years before, General Sherman had burned the city to the ground in the Battle of Atlanta during the Civil War. After the war, Atlanta began to rebuild—but it was only small wooden buildings at first. Then taller buildings went up, and brick and other materials were introduced. Mansions sprang up along the main road, Peachtree Street. But the Equitable was a skyscraper, just like buildings in New York or Chicago, and a harbinger for what Atlanta would become in the future. (AHC.)

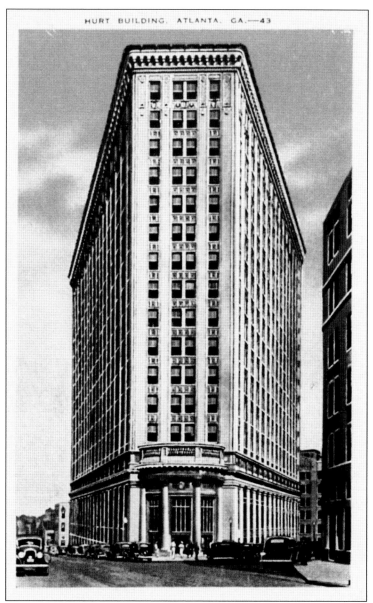

THE HURT BUILDING. After founding the Kirkwood Land Company, Hurt established the Atlanta Home Insurance Company in 1906. In 1911, he built the Atlanta Theatre, which stood until 1954. The Hurt Building was Joel Hurt's masterpiece. It was triangular and designed by J.E.W. Carpenter of New York. The Hurt Building stood 18 stories tall and towered over the city as its tallest building. It was considered the 17th tallest in the world. Construction began in 1913, but World War I interrupted its completion. Work resumed after the war, and its grand opening was in 1926. When compete, the building housed the Eighth Federal Reserve Bank of the United States. The first four floors, which completely filled the lot, provided a sturdy and solid base for the building. The upper floors were set back from the base and split into wings in a V shape. This design allowed a lot more light in the top 14 floors. The building contained a light-filled rotunda adorned with classical details. Today, the architecturally significant building remains highly visible downtown and is listed in the National Register of Historic Places.

27

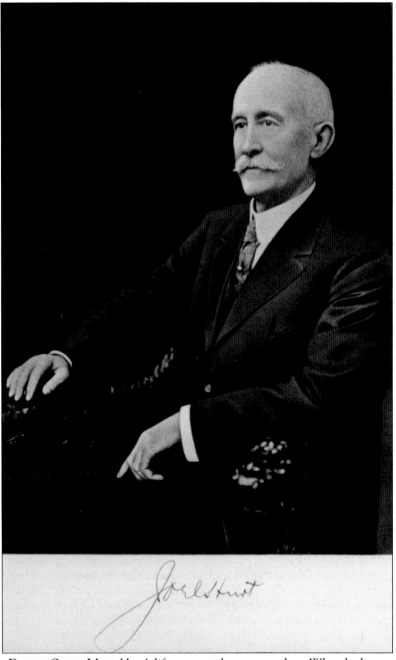

Joel Hurt [signature]

HURT AS A DAPPER OLDER MAN. Hurt's life was not always exemplary. When he began to expand his business empire to include mining interests, he relied on an arrangement used throughout the South after Reconstruction known as "convict leasing." This was a system where convicts were leased to a business or individual. Though Joel Hurt has been shown to have been involved in the deplorable state-sponsored program, no evidence has been found to date that Hurt utilized convict labor in building either Inman Park or Druid Hills. Joel Hurt is revered for his business acumen, buildings, trolley system, and the development of Inman Park and Druid Hills, but perhaps his most important contribution was having the vision and foresight to hire Olmsted. (AHC.)

Three

HURT, OLMSTED, AND THE DRUID HILLS CORPORATION

Joel Hurt's plan was impressive. He knew the right people to hire to help complete the plan. He had the will. He had the experience. He had money. But perhaps he did not have enough money to complete his development as he wanted. Perhaps he was ready to move to other endeavors. Maybe Asa Candler was pressuring him. Or perhaps he was simply tired. Whatever the reason, after Hurt had done the lion's share of organization, development, hiring, and planning, he was ready to let go of Druid Hills, knowing that by selling, the project would remain in good hands. What Hurt told others is that an opportunity presented itself to sell the property to men who would carry out his and Olmsted's plans. This seemed to be the impetus for Hurt to sell to a group of his friends led by Asa Candler who would complete the subdivision the way he wanted. Perhaps Hurt's idea was pretty savvy after all: he got to watch Druid Hills progress as he planned, and at the same time, he had half a million dollars from its sale.

 East Atlanta Land Company.

OFFICERS.
JOEL HURT,
President,
PHIL. H. HARRALSON,
Vice President,
LITT BLOODWORTH, JR.
Secretary

Atlanta, Ga June. 7, 1892, *18*

 East Atlanta Land Company

OFFICERS.
JOEL HURT,
President,
PHIL. H. HARRALSON,
Vice President,
LITT BLOODWORTH, JR.
Secretary

Atlanta, Ga _____ *18*

Messrs. F.L.Olmstead & Co.

Brookline, Mass.,

Gentlemen:-

 I have your favor of the lst.inst., We have engaged
Mr.S.Z.Ruff, an experienced Civil Engineer, who commences tomorrow making
surveys for the contour lines in the Kirkwood Land Co. property.

 It is our desire, as I wrote you some days ago, to engage your firm
for five (5) years to give direction to this work for us. Mr.Ruff wishes
to know, now, upon what scale you wish the map made, and to be furnished
with any instructions you may see proper to give. We think we have
secured in him a very good man. He is a graduate of the Engineering
School of the University of Georgia in the class of '92, in which he took
first stand, and has made a considerable reputation as an Engineer since,
chiefly in charge of railroad construction, however. He is a good
draughtsman and somewhat of an artist, and we hope that he will be com-
petent to carry out your instructions in case we come to an agreement
with your firm. At any rate, we will need a contour map, and will have
him prepare it.

 In regard to your suggestion to visit us, about the 23d.of June, I leave
this to your judgement.

 We have added about 430 additional acres, giving us now something
over 1400 acres. It did not take in much of the land that you thought
might be worked well with ours, however.

(F.L.O.& Co.)
#2

We will be guided largely by your advice in the amount of this land to be
developed at this time, but I am of the opinion that it all ought to be
laid out with a view to developing the whole of it.

 Awaiting your further advice, I am,

 Yours very truly,

 President,

HURT AND OLMSTED. Joel Hurt founded Kirkwood Land Development Company in 1892. As an amateur horticulturist, Hurt already knew of Frederick Law Olmsted Sr. and his work. He convinced Olmsted to come to Atlanta to see his land and consult on the project. In a momentous decision that would alter the planning of old Atlanta neighborhoods, Hurt hired Olmsted. Some of the other subdivisions and developments that came after Druid Hills, including Morningside, Avondale Estates, Ansley Park, and Garden Hills, have elements inspired by Olmsted's designs for Druid Hills. Olmsted's designs were not only significant in the Druid Hills neighborhood but also left his stamp on a lot of old Atlanta. (LOC.)

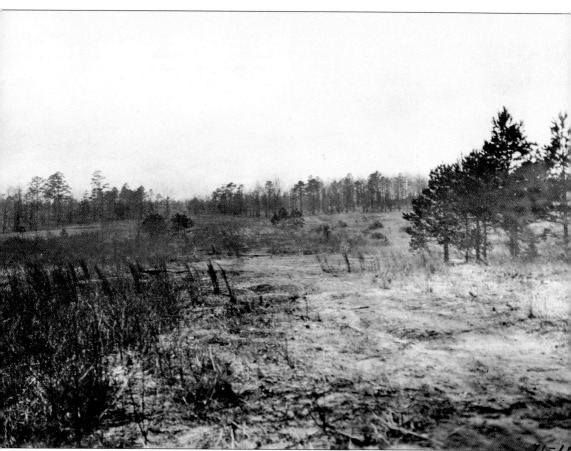

NOT A PRETTY PICTURE. When the Olmsted firm started plans for Druid Hills, it faced a mess. The red clay and meager soil had been over-farmed for decades and depleted of minerals and nutrients. As a result, trash trees such as jack pines were prolific. There was nothing inviting or picturesque about the land and no evidence it could be made into a recreational park or, as Olmsted Sr. called it, "a public pleasure ground." What role would this land play in the subdivision to be called Druid Hills? Could it really become a park? Or would it be better as sites for homes? And where would the roads and trolleys be located? It took genius to visualize what it might become—a genius provided by Frederick Law Olmsted Sr. (NPS Olmsted.)

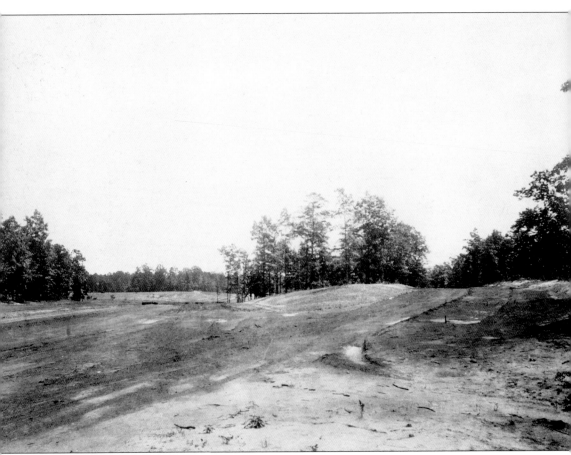

WHAT'S LEFT AFTER A WAR. When John Charles and Frederick Jr. saw and photographed Joel Hurt's land, it had been only 40 years since the American Civil War. Though the actual Battle of Atlanta took place just south of the Druid Hills property, both Union and Confederate soldiers traversed what was to become the linear park. General Sherman's Union headquarters were just northwest of the Hurt land near the present intersection of Briarcliff Road and North Decatur Road. Union soldiers set up a camp on land belonging to the Paden family, now part of the Druid Hills Golf Course, just across the street from the linear park. Confederate soldiers set up a camp slightly south and west of the Hurt land on what is today the Candler Park Golf Course. Though no actual battle took place on the Hurt land, soldiers, horses, wagons, and cannons had to cross what is today's linear park. (NPS Olmsted.)

Atlanta, Ga.June 8th, 1893.

Mess.Olmsted, Olmsted & Eliot.,

Brookline, Mass.

Dear Sirs:-

 Upon my return from Boston I have had an interview with Mr.Ruff in examining the maps furnished by you,showing plans for the main avenue through the property of the Kirkwood Land Company. We have an early appointment to spend two or three hours discussing the plans more fully, but at this time we desire to submit the following questions for your consideration:

Ist. Since it is almost certain that the approach to this property by surface railways will be by an extension of the Inman Park line, should not the line on Moreland Ave., which is a part of this extension, enter the property more directly than would be required in an extension along Moreland Ave. up to the initial point of your main avenue, as must necessarily be the case from the present plan? When Mr.Olmsted was here he rather favored entering the property near the corner as it is first reached on Moreland Avenue. Suppose you should not do this but prefer to extend the line along Moreland Avenue to your present initial point, would it not be even well to deflect the line East before arriving at your Avenue ?

(2)

2nd. Should not this line be intended solely for service in that portion of the property lying North of your main avenue which it is proposed to develop more elaborately hereafter,? and in this event, how would it do, in order to shorten the distance to Decatur, to approach your main avenue with a line built along the extension of the old turnpike leaving Moreland Ave. at the Academy, which you will remember, and entering the Company's land about Station 32, on the South boundary line of Section 2 , crossing the ravine here and making an easy approach to your main avenue; thence along your avenue to Decatur ? This would furnish a more direct travel to Decatur, and if occasion should arise to connect these lines for any special purposes, the short link of about 1000 feet separating them on the Main Avenue could be connected by a line to be used only on special occasions.

3rd. Mr.Ruff thinks that, instead of adhering rigidly to the grades fixed by you, which would be rather steep at places for an electric line, especially when these grades are of much length, it might be well to vary these grades somewhat as indicated by the pro-file which he will send you to-day, and upon this we would like your views .

4th . Since the acquisition by the Company of the property lying in the Northeast corner of Section I, as shown by plat recently sent you by Mr.Ruff, would it not be best to deflect the street car line North at a point about 800 or 1000 feet West of the G.C.

HURT'S IDEAL SUBDIVISION. Frederick Law Olmsted Sr. was to design Hurt's dream of the ideal subdivision and a linear park as the centerpiece for that subdivision. Meandering beside the linear park was to be the extension of Ponce de Leon Avenue (which at the time went only as far as Ponce de Leon Springs), a curvilinear road that followed the topography of the land. (NPS Olmsted.)

33

Hurt - 3.

Mr. Olmsted remembers that he suggested in the telegram
one or two names for consideration, Aside from those
names, the names already before us,it may be well to re-
peat, are as follows:-

Brightwood	Ponce de Leon	East End	Druidhills
Braehurst	Inwood	Homewood	Avondale
Oakhurst	Tallulah Hills	Homethorpe	Battleboro
Bonnybrae	Etowah	Bonville	Belvista
Highland	Woods of Arden	Valhalla	
Hightown	New Dorp		
Merrymount	Newton	Vernonchase	
Eden	Newtown	Bellbrook	
Atlanta Heights	Palos Altos	Berwyn	
Goodwood	Monticello	Lochrest	
Midwood	Mt. Vernon	Bluefield	
Florawood	Morningside	Aurora	

We venture to gently repudiate the imputation that
the matter of a name is of no interest to us. We have

CORRESPONDENCE. After Olmsted accepted Hurt's commission, his firm and the Hurt firm produced voluminous correspondence by letter and telegram. Nothing was too small to be identified, discussed, and settled upon. The Olmsted firm even suggested names for the new subdivision, as seen in this letter. Fortunately, this correspondence was saved and is now housed at Fairsted, the Olmsted national historic site in Massachusetts, and at the Library of Congress. Some of the names evoke other parts of the United States. Others seem made for villages in Great Britain. Still others hearken back to the Native American days. Some are just comical—what if Druid Hills had been named New Dorp? (LOC.)

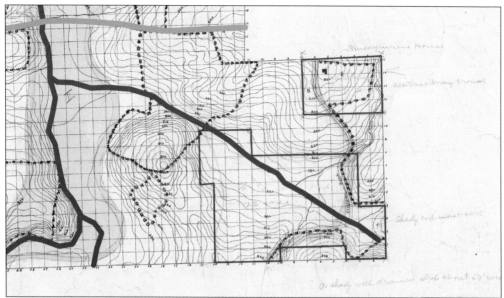

Handwritten annotations on map: Nurseryman's house, additional nursery ground, shady cool moist soil, a shady well drained strip about 50' wide

THE DRUID HILLS NURSERY.
Plants were a huge consideration for Olmsted. In 1894, he wrote to Joel Hurt that they would, under separate cover, send a "plan of the nursery ground which is divided into blocks . . . including the distance apart each plant should be and the kind of plants adapted to each block." This map shows the location of the nursery. (NPS Olmsted.)

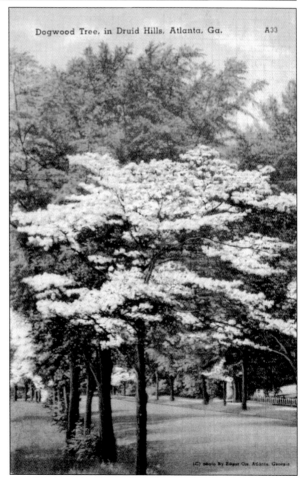

Dogwood Tree, in Druid Hills, Atlanta, Ga. A33

BEAUTIFICATION. The Olmsted firm was known for the variety of plants it used and for choosing plants for their beauty throughout the seasons. Dogwoods (*Cornus florida*) were used prolifically in Druid Hills. This image, taken from an old hand-tinted postcard, shows dogwoods in bloom along a section of South Ponce de Leon Avenue and Oak Grove Park.

35

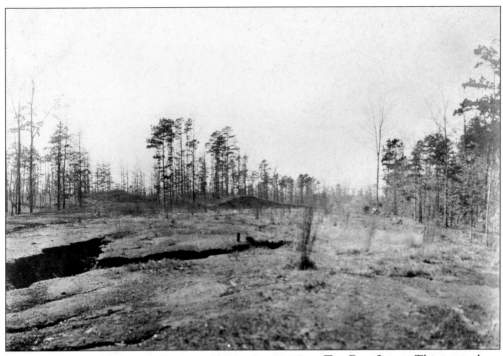

THE RAW LAND. This is another of the early photographs that show the raw land on which the Olmsteds had to work. The dark gashes show where significant erosion has taken place. In the early 20th century, all labor was manual. (NPS Olmsted.)

Hurt - 3.

With regard to the restriction as to animals, it does not seem to us important to limit the number of horses to four, and you might as well leave the number out. It was mentioned before because that is the number allowed in Brookline without a special permit issued by the Board of Selectmen. The intention of it, we presume, is not to prevent families from having more than four horses as much as to prevent livery stables and contractors' stables from becoming an annoyance to neighboring residents. Besides, it is a limitation which is of much more consequence where the lots are very often only a quarter of an acre or so, as they are in Brookline, and where a large stable with many horses would therefore be more likely to be objectionable. The Selectmen here do not grant the permit for more than four horses until after a hearing in which all who choose can object, and if the objections seem reasonable to the Selectmen, they refuse the permit. We feel very strongly the importance of the restriction against poultry, and we urge that you keep this in the restrictions, in spite of what any intending purchaser says. We think it ought to be an absolute restriction and not arranged so that the raising of poultry must be stopped after people in the neighborhood object, and of course the same restriction applies to hogs. The case with regard to domestic pets could perhaps be treated more gently, partly because people are

COVENANTS AND RESTRICTIONS. It was important that the subdivision have covenants and restrictions. Hurt and Olmsted had rules about pigs, horses, and chickens on the Druid Hills plots and how tall a hedge row might be. With concern to attract "a desirable class of people," minimum cost requirements were established for the houses. (LOC.)

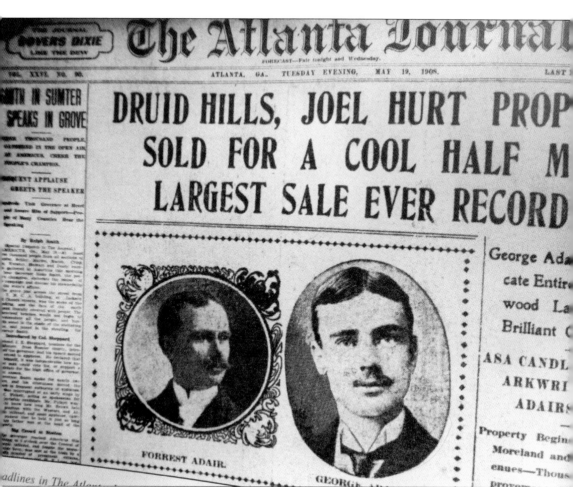

The Atlanta Journal

COVERS DIXIE LIKE THE DEW

FORECAST—Fair tonight and Wednesday.

VOL. XXVI. NO. 90. ATLANTA, GA., TUESDAY EVENING, MAY 19, 1908. LAST

DRUID HILLS, JOEL HURT PROP
SOLD FOR A COOL HALF M
LARGEST SALE EVER RECORD

SMITH IN SUMTER SPEAKS IN GROVE

FORREST ADAIR.

GEORGE A

George Ad
cate Entir
wood La
Brilliant (

ASA CANDL
ARKWRI
ADAIRS

Property Begin
Moreland and
enues—Thous

CHANGE. The history of the development of Druid Hills was about to change, as Hurt was considering selling. Two things converged to cause Hurt to sell the Kirkwood Land tract. First was that lots in Inman Park were not selling as quickly as Hurt hoped. Secondly, Hurt realized his plans for Kirkwood Land were going to be more expensive than he anticipated. He sold Kirkwood Land to a syndicate consisting of Asa Candler with controlling stock, Preston Arkwright, George and Forrest Adair, William D. Thomson, Harold Hirsch, and John S. Candler on May 19, 1908. Of the sale, Hurt said, "Now that an opportunity is presented to turn the property over to gentlemen who will carry out my plans and the designs of Mr. Olmsted, I am willing to part with the property." The sales price was a record $500,000. At the time of the sale, the land had been surveyed and some of the streets laid out, but nothing had been paved yet.

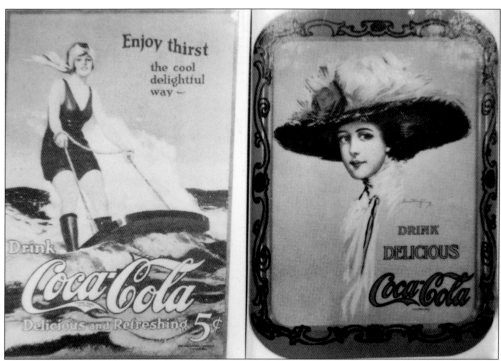

ASA GRIGGS CANDLER. Asa Candler (1851–1929) came to Atlanta to work as a druggist in 1873. He later fell in love and married the daughter of the owner of the drugstore where he worked. In 1880, Candler purchased the recipe for a tonic from John Stith Pemberton and marketed it as a fountain drink. In 1892, he formed the Coca Cola Company. In order to advertise Coca Cola, myriad items were given away, including calendars, trays, and small mirrors that ladies carried in their purses. Coke made Asa a very rich man. His Druid Hills residence is pictured below.

SALES. The Druid Hills Corporation was chartered on June 25, 1908, a month after the sale from Hurt. By December 1909, $86,000 worth of lots had been sold and $750,000 worth of lots had been optioned but not officially sold yet. The development was off to a grand start—and this was just the beginning. (Collection of Sally H. Harbaugh.)

The party of the first part agrees that the property indicated on the Plat of Druid Hills, lying between the right-of-way of the electric railroad and Ponce De Leon Avenue South, and extending from the land lot line dividing land lots 242 and 243 of the Fifteenth District, east to Deepdene Park and designated on said plat as Dellwood Park, and that property indicated on the Plat of Druid Hills, lying between the right-of-way of the electric railroad and Ponce De Leon Avenue North, designated on said plat as Deepdene Park, is hereby set apart and shall perpetually be reserved for park purposes, for the common use and enjoyment of the owners from time to time, and their families of the lots in Druid Hills, and the party of the first part, its successors and assigns, and the owners of such other lots and such other persons as from time to time the party of the first part, its successors and assigns may admit to the use and enjoyment of the said parks. The party of the first part hereby reserves to itself, its successors and assigns, the right to prescribe from time to time such rules and regulations as it may deem proper for the use of said parks, to place such restrictions on the said use as it may deem wise, to dedicate said parks to general public purposes should it, its successors and assigns, at any time deem proper; and generally to reserve and maintain full power and authority over the said parks.

To HAVE AND To HOLD the said tract or parcel of land with all and singular the rights, members and appurtenances thereof to the same being, belonging, or in any wise appertaining to the only proper use, benefit and behoof of the said party of the second part, **her** heirs and assigns forever, in Fee Simple.

AND THE SAID party of the first part, for itself, successors and assigns, will warrant and forever defend the right and title to the above described property unto the said party of the second part, **her** heirs and assigns, against the lawful claims of all persons whomsoever.

IN WITNESS WHEREOF, the said DRUID HILLS, acting through its President and Secretary, has hereunto set its hand and caused the seal of the Corporation to be affixed, the day and year first above written.

Signed, Sealed and Delivered in the Presence of

DRUID HILLS,

J C Ray

By _Chas H Candler_
President.

B. G. Smith
Secretary.

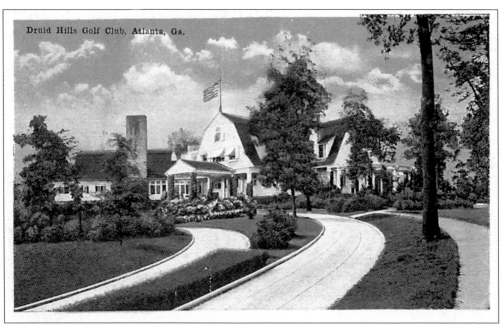

Druid Hills Golf Club, Atlanta, Ga.

A GENTLEMAN'S CLUB FOR DRUID HILLS. Candler helped finance and found the Druid Hills Golf Club in 1912 at the corner of Clifton Road and Ponce de Leon Avenue. Asa's idea was to have a gentlemen's club. It had tennis courts, a pool, a clubhouse, and 18 holes of golf. A young Bobby Jones was the first club champion. Edward Dougherty designed the clubhouse, and H.H. Barker designed the golf course.

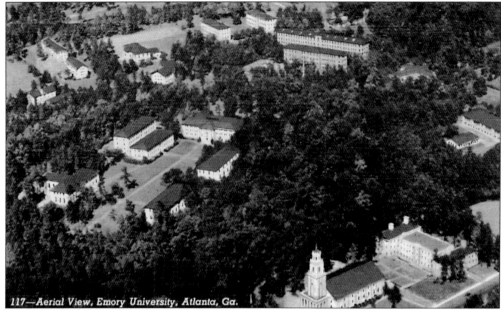

117—Aerial View, Emory University, Atlanta, Ga.

EMORY UNIVERSITY IN ATLANTA. Candler's gift of land and $1 million helped bring Emory at Oxford College to Atlanta as Emory University in 1916. The quadrangle was the center of the campus with the library and School of Theology built of pink and gray marble. Emory would later add professional schools of medicine, nursing, dentistry, and law and undergraduate and graduate programs.

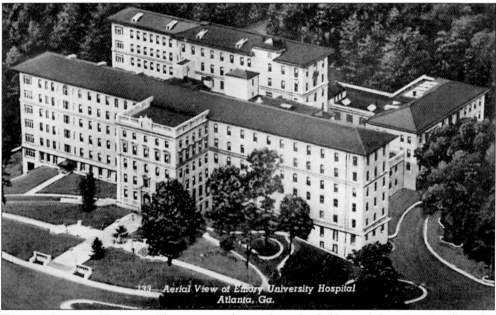

133—Aerial View of Emory University Hospital
Atlanta, Ga.

WESLEY MEMORIAL HOSPITAL. The university hospital was funded by a gift from Asa Candler, who gave many substantial bequests to Emory University. The hospital was named for John Wesley, founder of Methodism. The original hospital faced Clifton Road, and many additions and wings were built through the years. Today, the Clifton Road campus has numerous buildings that make up Emory Healthcare and owns other hospitals and health care facilities in the metro Atlanta area.

Four

OLMSTED'S DESIGN FOR THE PARK, LOTS, AND ROADS

There are a number of misconceptions regarding the restoration, rehabilitation, and reconstruction of a historic landscape. The first is that it is simple to do: "All you had to do was use the old plans again and just do what those said, right?" No: there was nothing simple about it.

The project began nearly 130 years ago, and documentation for a landscape architectural project was very different in the 1890s than it is today. Communication was difficult; there were no faxes, no emails, no texts, and few photographs of action on the ground. There were telegrams and letters—oh, the letters! The project itself experienced many starts and stops from inception to construction as well as the sale of the land to a new owner, meaning the potential loss of momentum and information.

Nomenclature had not been standardized in the field of landscape architecture, so reading and interpreting a planting plan from the early 20th century feels like reading hieroglyphics. As with ancient Egypt's records, what was critical was a means of translation. Finally, a Rosetta Stone was found: nursery records that explained the code used on the planting plans as well as a lengthy inventory of what was brought to the onsite nursery for installation in the parks.

The work to restore, rehabilitate, and replant required a curious mind and the ability to read between the lines. It also required the ability to set aside a designer's ego and ask, "What were Olmsted and Hurt trying to do?" This was the guiding mantra. Thousands of plants later, the shape and feel of the park are much as they were in the mid-1920s.

ATLANTA 1892. The Olmsted firm included a contextual map from 1892 that showed the size of Joel Hurt's holdings relative to the city of Atlanta. Hurt's Kirkwood Land Development Company was nearly the size of the then city limits, with the center of the city shown in the bull's-eye near the location where three major railroad lines converged. The city of Atlanta was a circle with a radius of about 1.75 miles. Its area was approximately 1,960 acres in 1892, when design work began. The Kirkwood Land Development Company—what would become Druid Hills—covered 1,400 acres, an area more that 70 percent of Atlanta itself. The western edge of Druid Hills is about three miles from the traditional city center. Today's well-known Buckhead community is quite literally not on the map, and Peachtree Road, which leads there, is simply one of a dozen or so country roads radiating from town. By far the most important transportation routes of the time were the railroads, which figure prominently in this graphic. (NPS Olmsted.)

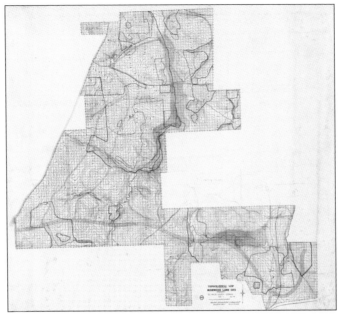

KIRKWOOD LAND DEVELOPMENT COMPANY: OLMSTED'S LAST RESIDENTIAL SUBURB. First and last, there is a cruciform organizational structure that contrasts the natural environment of river and creeks with railroad, trolley, and parkway. In both Riverside and Druid Hills, riverine systems and their floodplains form the basis for parks and even lakes. The creekside parks shown above were not built. Paralleling the trolley in Druid Hills was a parkway responding to the gentle grades of the Piedmont, an element particularly pleasing to Olmsted. The park along Ponce de Leon Avenue was built. The land includes ridges that run from the northeast to the southwest. The image above, showing the initial wide boulevard Hurt requested, is dated March 18, 1893. The image below is from later that year and shows the parkway Olmsted preferred, which was adopted and built. (Both, NPS Olmsted.)

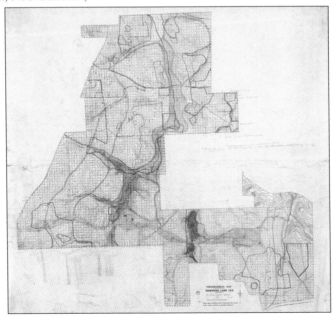

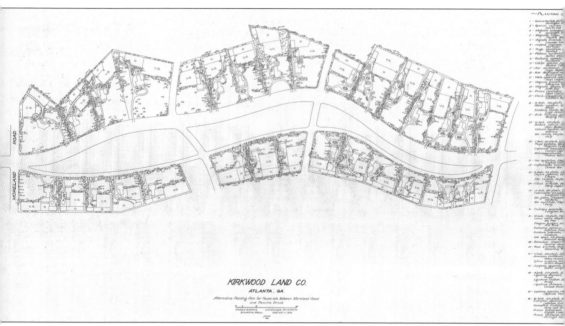

KIRKWOOD LAND CO.
ATLANTA, GA.

Alternate Planting Plan for Route-lots between Moreland Road
and DeLeche Brook

Olmsted Brothers Landscape Architects
Brookline, Mass. March 4, 1906

A Six-Foot-Long Planting Plan. Among the first planting plans for the suburb were those for proposed lots along the first several blocks of Ponce de Leon Avenue just east of Briarcliff Road (the old Williams Mill Road). To illustrate how this could be built, the firm provided plans that showed houses, drives, stables, and other improvements along with planting so that a buyer could see ways in which these suburban estates might come into being. The Olmsted firm provided

44

examples of what could be done to illustrate what was essentially a new building type in the Atlanta market: the suburban villa in the manner of Andrew Jackson Downing and Alexander Jackson Davis, the 19th-century tastemakers whose writings were so influential. The image is dated March 11, 1903. (NPS Olmsted.)

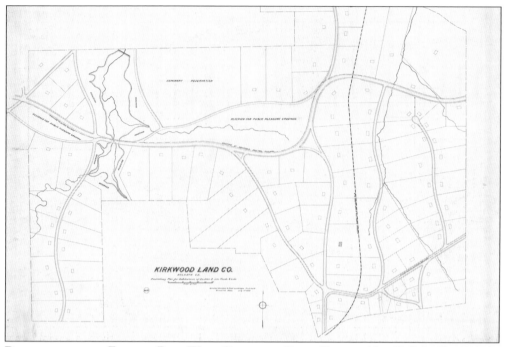

DRAWINGS FOR THE EASTERN PART WERE COMPLETED FIRST. Drawing No. 60 (July 17, 1893), for Section I, shows how the roads and lots would be laid out and includes the Georgia, Carolina & Northern Railroad, what would become Deepdene Park, Dellwood Park, and the 13-acre easternmost proposed lake, called Widewater in later plans. Nearly 29 acres were set aside for a seminary that was not built. The northeast corner of the initial 1,400-acre tract was given to Emory University by Asa Candler. The roughly 22-acre tract that would become the forest known as Deepdene Park is the one constant through all the various plans developed between 1892 and 1905. It was clearly viewed as an important resource worth preserving. Drawing No. 53 (below), dated June 21, 1893, shows a "Revised Preliminary Plan for the Eastern End of the Avenue." The stationing drawing shows both the principal avenue and the trolley line. That such a technically advanced drawing was being produced so early in the process is an indication of extreme confidence. (Both, NPS Olmsted.)

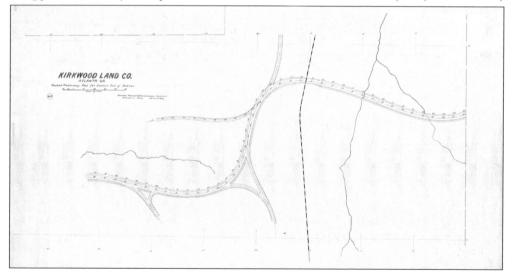

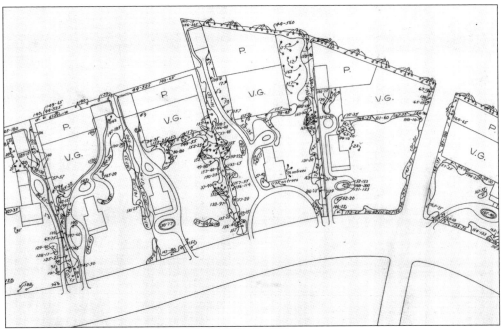

PLANTING PLAN NO. 107, MARCH 11, 1903. Plans like these were created for the first several blocks and the first three park segments at least. The designs called for large lots for suburban houses with frontages of several hundred feet. Olmsted wanted to create a feeling of large estates. By the time Druid Hills was under construction in the early 1900s, cars were growing in popularity, though each lot along Ponce de Leon Avenue included a vegetable garden and a paddock, shown by the "P" and "V" on the plans. Routine maintenance for horses included picking hooves and mucking stalls. A paddock was a convenient turnout area for both activities. The vegetable garden was a necessity, as a local greengrocer was some distance away and the convenience of frozen foods was not developed until 1924. The Olmsted plant palette was extensive, varied, and included plants considered anathema today. Plant No. 44 on the plans refers to a variety of privet; some of the original hedges remain today, as seen below. (Above, NPS Olmsted.)

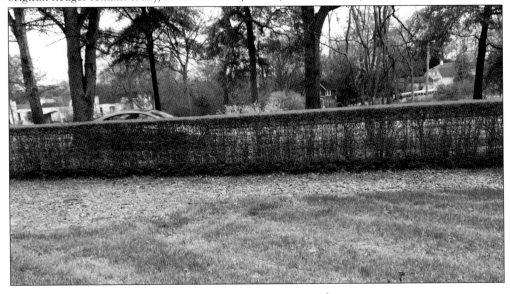

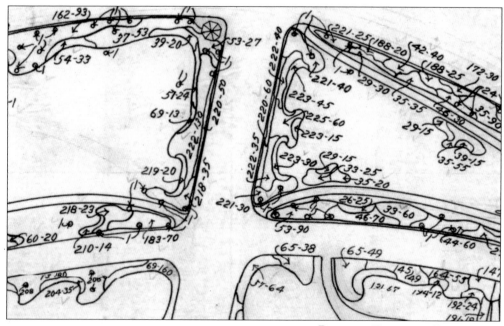

No. and Alter.	Scientific and Popular Name		Quan.	Total Quan.	Size and Condition	Where from	Price	By	Cost	Estimates and N
1	Quercus Phellos Darlingtonia — Darlington Oak		53							53 = 53
3	" coccinea — Scarlet Oak		2							2 = 2
4	Magnolia soulangeana — Soulange's Magnolia		3							3 = 3
5	" Fraseri — Fraser's Magnolia		15							15 =
6	" acuminata — Cucumber Tree		9							9 =
8	Juniperus virginiana — Red Cedar		34							34 =
9	Tsuga canadensis — Hemlock		5	234						234 =
12	Platanus occidentalis — Button Wood		6							6 =
13	Paulownia imperialis — Paulownia		1							1 =
15	Catalpa speciosa — Western Catalpa		5							5 =
17	Acer saccharinum — Sugar Maple		7							7 =
20	" dasycarpum Wieri — Wier's Cut-leaf Maple		6							6 =
21	Melia azedarach umbraculifera — Texas Umbrella China		4							4 =
22	Magnolia grandiflora — Evergreen Magnolia		8	76						76 =
23	" glauca — Sweet Bay		8	69						69 =
24	Prunus caroliniana — Mock Cherry		4	24						24 =
25	Ilex aquifolium — Southern Red Ced		8	4						4 =
26	34 beds 1780 plants		2							1780 =
	Abelia rupestris — Abelia			1000						
	Gardenia florida — Cape Jessamine			780						
27	Rosa filipes penduliflora — Weeping Thread-leaf Rose		3	39						39 =
29	33 beds 1294 plants		3							1294 =
	Berberis japonica — Japan Barberry			350						
	Mahonia aquifolia — Mahonia			400						
	Ilex cornuta — Holly			544						
	Amounts									

PLANTING PLANS AND PATH LAYOUTS.

Plans from the Olmsted firm for the first three park segments were used for the restorative planting and path construction in those segments. One major change was the elimination of walks that crossed the body of each park and led to former trolley stops. The Olmsted firm included native and nonnative shade trees, understory trees, ornamental shrubs, vines, and groundcovers: the entire palette of plants that would create the appropriate setting for houses and pastoral spaces of great beauty. A plant list became the restorers' Rosetta Stone assisting in the translation of the Olmsted coding, a very different nomenclature used in the early days of landscape architecture. The sheer volume of planting on the project made an onsite nursery practical. There, "liner stock" was planted, a cheap and effective way to provide plant material for such a large project. The Olmsted archive holds extensive correspondence between the firm and Hurt concerning stocking the nursery. (Both, NPS Olmsted.)

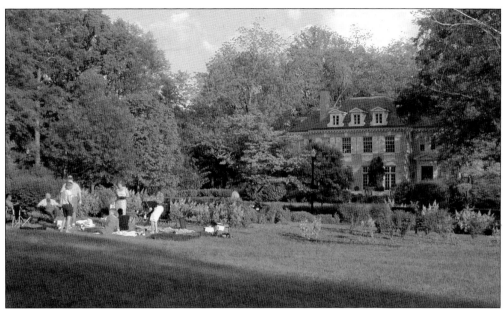

DÉJEUNER SUR L'HERBE. Even before rehabilitation was complete, people came to the park for impromptu picnics, jogging, strolling, reading, or simply enjoying being out of doors as Olmsted had hoped. The elegant Adair-Ashcraft house, by Neel Reid, is flattered by planting along South Ponce de Leon Avenue, used by the Olmsted firm to obscure roads and provide the feeling that the properties that bordered the park flowed naturally and seamlessly from property to property and into the park itself. What old-timers call Judas trees, better known as redbuds, were one of the many native trees used by the firm and highlighted in the restoration of the park. The park bench in Oak Grove is put to good use by Paideia School students. Georgia's youngest senator, Jon Ossoff, is an alumnus of the school, which sits adjacent to the park. The paved paths, initially thought to be damaging as a source of runoff, have a benign effect in the park, acting as a device that welcomes users like a warm handshake.

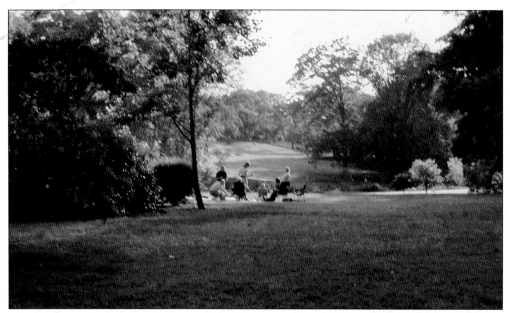

PASTORAL VISTAS. Segments of Virgilee and Springdale highlight aspects of this open, gently rolling component of Olmsted's design ethos. Though this park is narrow, it is long. From inside a car, the narrowness dominates; on foot, the experience changes markedly. Enjoying an afternoon with friends, the park takes on the qualities of transcendence that Olmsted was hoping to evoke. Above, the high point of Virgilee is appreciated as the pivot point in the first three park segments. From here, the sweeping breadth of Springdale can be enjoyed, and the roadway between park segments drops out of view. In Central Park, Olmsted and Vaux famously suppressed the four streets that cross the park. In Druid Hills, the roads that cross the parks are visually suppressed by both grade and planting. The effect is similar without the greater expense. From the vista point Olmsted created in Springdale, all three of the first park segments are visible but not obvious, teasing rather than forcing a park user forward. (Below, Followill.)

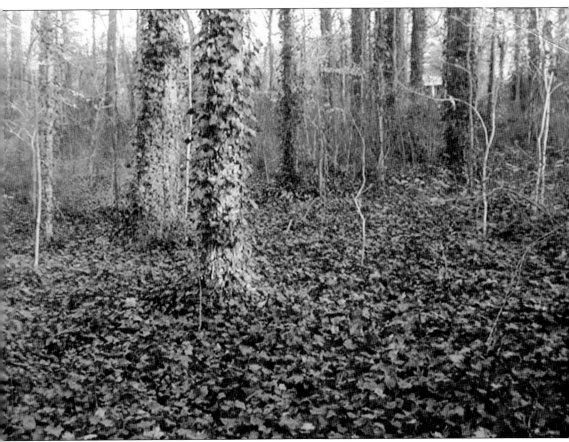

THE FOREST. Deepdene Park was the last park segment to be rehabilitated by the Olmsted Linear Park Alliance. About half the total park acreage at 22 acres, Deepdene was also the most complex. Intensive infrastructure issues, steeper grades, severe erosion, and severe infestation of invasive exotic plant material, such as English ivy, all contributed to make Deepdene a daunting prospect. It was only after the successes and confidence earned in the first five pastoral park segments that the OLPA board felt the time was right. A four-acre demonstration project showed that invasive plants can be tamed, steep grades managed, gorges crossed, and trees planted. Once the ivy blanket was removed, native plants emerged from the seed bank where they patiently waited for a return to more favorable growing conditions. The earlier practice of burning leaves and brush, banned over 50 years ago, destroyed many weed seeds. Since then, leaf blowers have accelerated the spread of invasive exotic plants, aiding their distribution of seed.

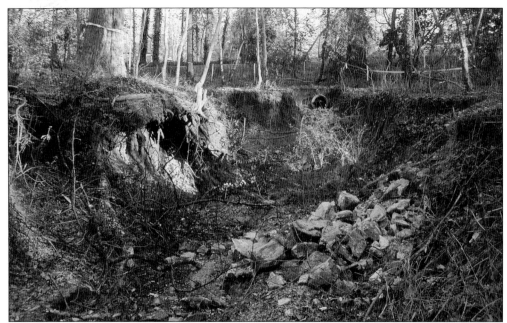

SCOUR PIT. Among the changes that resulted from the sale of the land from Hurt to Candler was a certain lack of understanding of the subtleties of the Olmsted design ethic. Candler assured Hurt he would carry forward Olmsted's plan, and his intent was good, though his follow-through was somewhat lacking. What was lost was some of the finer points of engineering, and the budget became an ever more severe taskmaster. A bridge over Peavine Creek between Dellwood Park and Deepdene was eliminated in favor of a culvert. Another bridge at the outfall of Deepdene Creek at North Ponce de Leon Avenue was also swapped for a culvert. The pipe entering Deepdene was treated brusquely, and the result after 100 years was severe erosion to the peril of trees and pedestrians alike. Modifying this condition involved the construction of a drop structure and the restoration of the stream with a series of cross vanes, pools, and riffles, better known as the Rosgen Method.

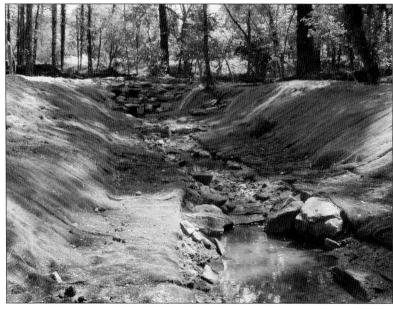

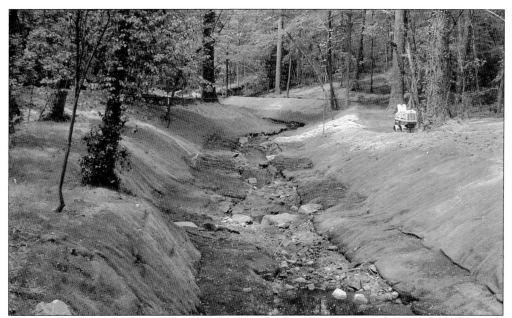

STREAMS HAVE A JOB TO DO. Part of this job is to carry their load of sediment. When the stream cannot do its job, sediments drop to the bottom, and the flow must push through this mass. Each storm brings changes to the system and, as the philosopher notes, you can never enter the same stream the same way twice. Restoring a stream is as much an art as it is a science, and this work was put to the test almost immediately after construction with severe hurricanes and a 500-year storm in 2009. The work held up beautifully. The graded slopes, stabilized with coir fabric, were planted with select water-loving plants perfectly adapted to the site conditions. The planting budget for this area was reduced to one third of its initial estimate to allow for other expense overruns. This is behavior that Olmsted certainly would have recognized. Within a few short years, no one could possibly tell the difference, evidenced by the picture below of the same area.

HIGHWAY DESIGNATIONS. Ponce de Leon Avenue bears four federal highway numbers as well as two state route designations. During the Great Depression, Druid Hills residents celebrated the state highway department takeover of the maintenance of their signature street. This relationship became less than mutually appreciative in the 1960s. An array of power lines followed the route of the trolley and caused the ritual shearing of the forest edge along Deepdene Park.

THE PROMENADE. This path along Ponce de Leon Avenue is set back almost 20 feet from the travel lane with the verge planted with 61 tulip poplars, the predominant tree species in the forest. Utilities were buried during this phase of work, and the poplars, used to great effect at Olmsted's Biltmore House, have matured beautifully but are at risk due to threatened activity by GDOT.

Five

INTRUSIONS AND THREATS TO OLMSTED'S PLAN

Any land set aside for a park needs ongoing care and maintenance. At first, the plan was for residents living around the linear park to maintain it. Many of the residents, being wealthy, sent yard workers and gardeners in their employ to manage the needs of the park. Dead trees and shrubs needed to be replaced, shrubs pruned and shaped, grass mowed, flowers dead-headed, leaves raked, and dead and fallen limbs removed. But the nearby residents' care of the park did not last long. Eventually, different segments of the park were given to the City of Atlanta, DeKalb County, and Fernbank Inc. with the understanding they would maintain the park. Other groups stepped in to help maintain the park as well, including the Druid Hills Garden Club, founded in 1928 and still in existence. During the 1940s, workers from the Works Progress Administration (WPA) built stone structures in the park. In the 1950s, a City of Atlanta Parks Department playground was added in the middle of Springdale Park. Later, the Howard School built a wooden playscape in Springdale. In 1988, Fernbank Museum of Natural History wanted to put its experimental rose garden in the center of Dellwood Park. Perhaps the biggest intrusion was the plan for an expressway that would bisect many in-town neighborhoods and destroy much of the linear park.

ATLANTA, DEKALB COUNTY, AND FERNBANK. The first four and a half park segments were deeded to the City of Atlanta Department of Parks and Recreation. The rest of Dellwood and Deepdene were deeded to Emory University and later Fernbank Inc. Atlanta maintained its portions of the linear park, and the county maintained the DeKalb portions. At times, this work amounted to merely cutting the grass and removing dead trees in danger of harming people or property.

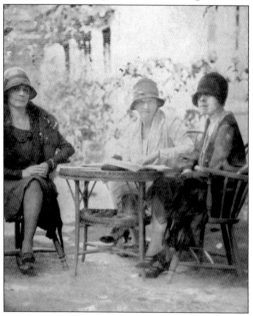

DRUID HILLS GARDEN CLUB. The club was present at the founding of the Garden Club of Georgia in Athens with the ladies in the photograph. They informally adopted Oak Grove Park as a club project. They built a granite fountain covered in vines, azaleas, and ferns as a memorial to some of their members and their families. They also constructed paths surrounding formal boxwood and rose gardens.

THE FIRST FOUNTAIN.
The original stone fountain, built as a memorial by Druid Hills Garden Club members, had several terraced tiers of granite with a plume of water in the top center that splashed down the various layers. Ferns and azaleas were planted prolifically around the fountain. A plaque at the base listed the club members and their family members who had died.

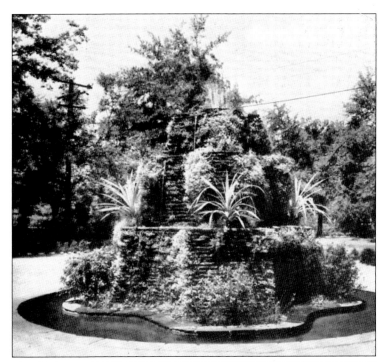

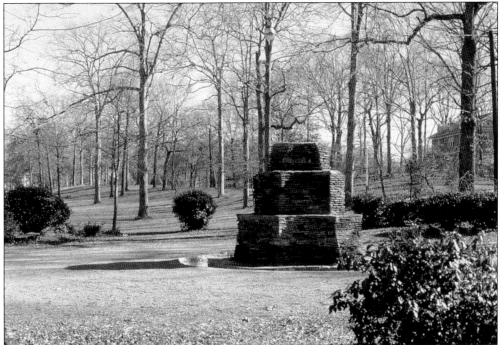

THE SECOND FOUNTAIN. The City of Atlanta demolished the original fountain and replaced it with a much less artistic granite fountain that had no plantings around it. One cold winter, the parks department failed to turn off the water to the fountain, and the water froze and broke the fountain apart. This later fountain was never repaired. Structures such as these had little to do with Hurt's or Olmsted's vision for the park.

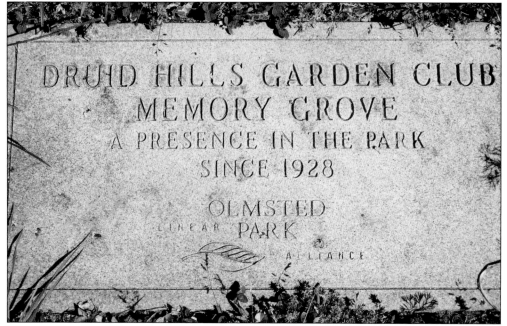

MEMORY GARDEN. When the park was renovated, the Druid Hills Garden Club fountain was removed and a plaque installed to recognize the years the club had worked in Oak Grove. The ladies continue to plant dogwoods in Oak Grove in memory of club members who have died. This is called the Memory Garden.

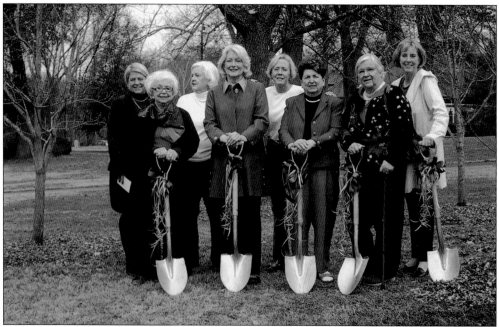

MEMORIAL TREES. Since its founding in 1928, the Druid Hills Garden Club has continued the tradition of planting dogwoods or redbuds in Oak Grove Park to recognize members who have died. Here members prepare to break the ground for a dogwood. The club's memorial trees are in alignment with the Olmsted planting plan.

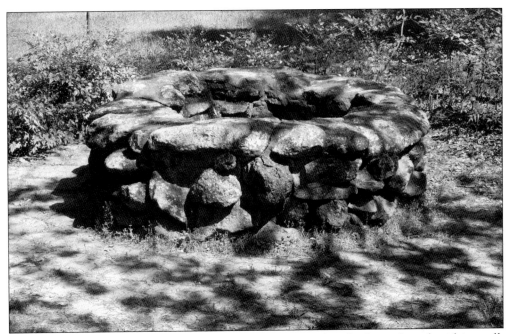

ROCK WISHING WELL. In the 1930s, another intrusion arrived in the form of a rock wishing well, rock garden, and curving stone bridge in Shadyside Park. Since the work was similar to other rock work in Georgia during the Roosevelt administration, these rock structures were most probably built by WPA workers.

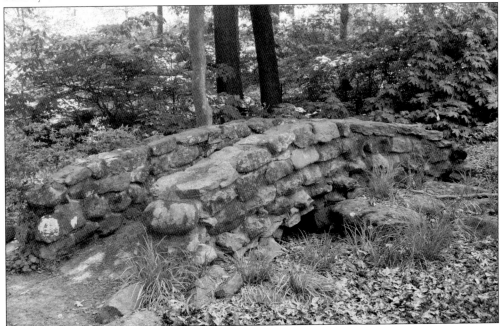

STONE BRIDGE. This primitive curving rock bridge was built at the same time as the wishing well. It crosses over a wet-weather draw, a place where a small amount of water flows or water only flows after a heavy rain. Quaint and picturesque, the WPA additions remained in the park because they illustrate change over time.

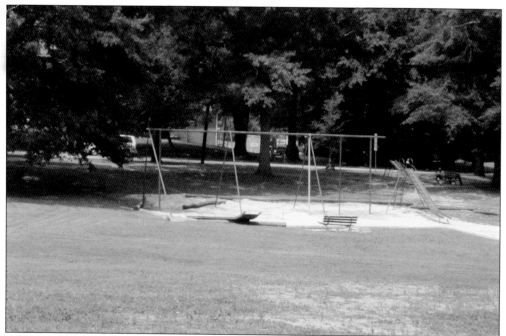

PLAYGROUNDS. At some point in the early 1950s, a major non-Olmstedian intrusion was introduced into Springdale Park. The Atlanta parks department installed swing sets, monkey bars, a nonmotorized merry-go-round, and a softball field. The field had a chain-link fence backstop and bases laid out in a trail of sand with a grassy infield. This playground was in the center of Springdale Park. Much later, the Howard School placed a wooden structure in Springdale for its students to play on, and it remained there until condemned due to safety violations. The wooden playscape was removed by the city.

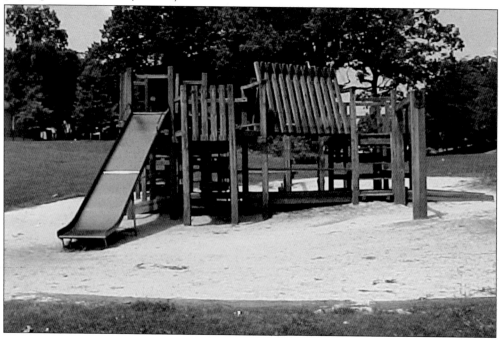

THE LOCHNER PLAN. In 1946, the state paid for the Lochner Transportation Plan. It showed the eventual interstates I-75, I-85, I-20, I-285, and I-485 and a toll road from Stone Mountain to town. It detailed bus and rail routes that were never built. It incorrectly assumed that the Downtown Connector—where two interstates join each other and cut a swath through downtown Atlanta—would be used as a state-to-state commuter road.

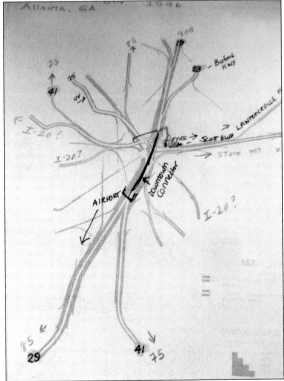

MORE EXPRESSWAYS. The plan contained hints of what was to come: Georgia 400 (to the North Georgia mountains) and the Perimeter (I-285)—a circumferential highway. The Downtown Connector was used primarily by residents and is now eight lanes and growing. It has become the main thoroughfare to get anywhere in Atlanta. If readers think expressways eventually harmed Atlanta, then the Lochner document was the plan for this destruction.

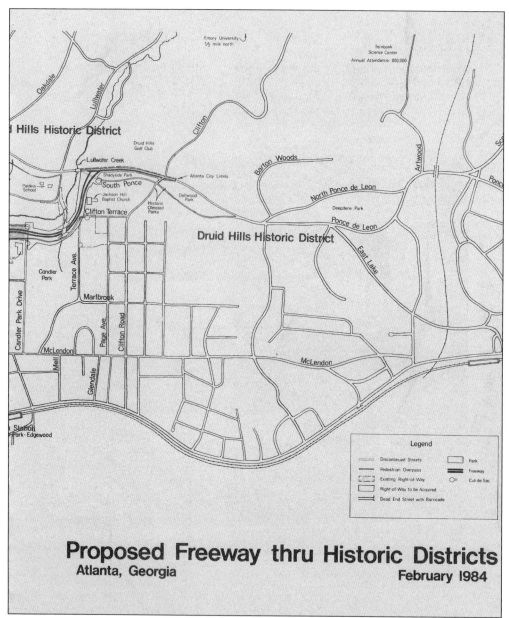

Proposed Freeway thru Historic Districts
Atlanta, Georgia February 1984

(Map labels include: Emory University ½ mile north, Fernbank Science Center Annual Attendance: 800,000, Oakdale, Lullwater, Clifton, Hills Historic District, Druid Hills Golf Club, Lullwater Creek, Barton Woods, Artwood, Shadyside Park, South Ponce, Atlanta City Limits, Paideia School, Jackson Hill Baptist Church, Dellwood Park, North Ponce de Leon, Deepdene Park, Clifton Terrace, Historic Olmsted Parks, Druid Hills Historic District, Ponce de Leon, Candler Park, Terrace Ave., East Lake, Candler Park Drive, Marlbrook, Page Ave., Clifton Road, McLendon, Mell, Glendale, McLendon, Station Park-Edgewood)

Legend

Discontinued Streets	Park
Pedestrian Overpass	Freeway
Existing Right-of-Way	Cul-de-Sac
Right-of-Way to be Acquired	
Dead End Street with Barricade	

STONE MOUNTAIN TOLLWAY/EXPRESSWAY/PRESIDENTIAL PARKWAY/FREEDOM PARKWAY. These names all refer to the same expressway through the years, a four-lane road that would bisect and most likely destroy several in-town neighborhoods. Between 1961 and 1992, many plans for the Stone Mountain Tollway expressway were presented, and by the late 1970s, it appeared as if the road would become a reality. Businesses in the Little Five Points area, the Old Fourth Ward, and Emory Village at times supported the expressway because they thought it would increase business for them. Many stores in Little Five Points had placards in their windows that read "Expressways are the lifeline of our economy." The expressway would destroy Deepdene Park, parts of Fernbank Forest and the Cator Woolford Gardens, and several other segments of the park. It also cut through several established, historic in-town neighborhoods. Neighbors were outraged and vowed to fight this destructive expressway.

History of the Carter Parkway

From published accounts and court records

Stone Mountain Toll Road Study Commission established by then Gov. Jimmy Carter issues report that Stone Mountain Toll Road should not be built.	**Apr 23** Georgia Supreme Court voids the land transfer, charging DOT with full knowledge of Arrington's conflict of interest.
	Apr 23 11th U.S. Circuit Court of Appeals remands the case to the U.S. Secretary of Transportation because of inadequate assessment of road alternatives.
Former President Jimmy Carter formally announces his plan to locate his library in the Great Park.	**May 20** Atlanta City Council votes 18-0 to reaffirm outside original conditions of its July 6, 1982 resolution to the land transfer.
Andrew Young, campaigning for mayor of Atlanta, takes a stand against new multilane roads in the city–specifically including roads in the Great Park.	**June 7** DOT files suit in DeKalb Superior Court to condemn the conditions. Hearing set for July 1.
	June 20 DOT orders contractors to resume work on the parkway.
After election, Young changes his position and asks Muldawer and Moulrie Architects to design the Presidential Parkway.	**July 2** Protests in Goldsboro Park. 90 Protestors arrested. Judge Clarence Seeliger rules that Georgia law does not permit condemnation of public land, and issues a permanent injunction against the project.
The Atlanta City Council approves 11-8 a compromise version of the mayor's Great Park proposal with restrictions on lanes, speed limit and a limit on widening of Ponce de Leon.	**Sept 16** 11th Circuit rules all contracts cancelled.
CAUTION is formed by 9 neighborhood associations to preserve parks and historic districts from the threat of road construction.	**Oct** Georgia Supreme Court rules that there is no authority to condemn public parks.
The Atlanta Regional Commission strikes the Decatur Parkway from the regional transportation plan and substitutes the Presidential Parkway.	**1986** **March** Georgia General Assembly establishes State Commission on the Condemnation of Public Property.
	Apr 25 DOT and FHWA issue new conclusion that the parkway would not be harmful to parks and historic districts.
Georgia DOT releases its Draft Environmental Impact Statement on the parkway.	**June 6** FHWA moves for a summary judgement in federal district court.
DOT holds a public hearing on the parkway at the Atlanta Civic Center. Over 3,000 road opponents attend to publicly condemn the proposal.	**Sept 26** Commission on the Condemnation of Public Property meets to approve condemnation of parkland owned by the City of Atlanta in DeKalb County.
	Oct Georgia State Supreme Court supports WSB request to set land condemnation of WSB land due to potential injury to from ice falling from WSB tower.
The National Advisory Council on Historic Preservation holds a hearing in Atlanta and votes against the road.	**Dec 23** Judge O'Kelley grants the motion for a summary judgement out allowing any opportunity for challenge of DOT findings.
Contracts on road are let.	**1987**
CAUTION and the National Trust for Historic Preservation file suit in U.S. District court.	**Sept** DOT Commissioner Rives outlines plan for covering over roadway, bike trails and jogging paths to protect public from ice falling from WSB tower.
Ground-breaking is held for the Carter Presidential Library.	
Contractor bids for the Parkway are opened.	**Dec 16** O'Kelley's decision is affirmed by the 11th Circuit Court of Appeals.
U.S. District Judge William O'Kelley rules in favor of the road, citing the possible loss of the Carter Library as a major consideration.	**1988**
Atlanta City Council votes in favor of a land transfer for the parkway. Council President Marvin Arrington participates in the voting and fails to indicate he is the minority contractor on the winning bid.	**May 19** CAUTION appeals to the U.S. Supreme Court.
	July 25 DOT files for condemnation of parkland in DeKalb County.
	Aug 24 Intervenors file motion for a trial by jury in DeKalb Superior Court.
DOT awards parkway bids to Shepherd Construction (with Marvin Arrington) and Arapaho Construction.	**Sept 11** *Atlanta Journal-Constitution* front-page article states that traffic counts were juggled to justify the roadway.
Road opponents file suit over conflict of interest.	**Sept 16** FHWA receives letter from Congressman John Lewis asking for investigation into allegations that Ga. DOT falsified traffic counts to justify proceeding with the Presidential Parkway.
ROADBUSTERS, a road protest group, erect a "tent city" in Frederick Law Olmsted's Shady Side Park.	**Sept 22** DeKalb County Superior Court Judge Seeliger holds hearing on DOT parkland condemnation suit, orders mediation, and continues restraining order.
The 11th U.S. Circuit Court of Appeals, CAUTION seeks to return O'Kelley's decision.	**Oct 5** DOT appeals Seeliger ruling to Ga. Supreme Court.
Fulton Superior Court Judge Osgood Williams grants a temporary restraining order. All construction is halted.	U.S. Supreme Court refuses to hear appeal of O'Kelley decision by neighborhood opponents.
Atlanta City Council passes a resolution 10-4 calling for a to the parkway.	**1989**
DOT bars Shepherd Construction indefinitely from bidding on state road projects. The firm is called "an unreliable bidder."	**Feb 20** Oral arguments before Ga. Supreme Court on DOT appeal of Judge Seeliger parkland condemnation ruling.
Young vetoes the Council's resolution.	**April** Ga. Supreme Court ruling has not been issued on DOT appeal of Seeliger ruling.
Judge Williams rules that the land transfer was valid, but that Arapaho Construction's contract is void.	**May** Hearing to be held in Fulton Superior Court by Judge Fryer to consider DOT proposal for ice cover over roadway in area near WSB tower.

THE ESTABLISHMENT. Those behind construction of the expressway included the Georgia Department of Transportation, the mayor of Atlanta, the Atlanta City Council and other Atlanta governmental groups, the governor of Georgia, the Atlanta Regional Commission, Central Atlanta Progress, the chamber of commerce, and many influential Atlanta business leaders. As time went on, opponents of the road faced mayor and former UN ambassador Andrew Young and former president Jimmy Carter. Carter wanted the road because it would provide four-lane access to his presidential library on Copenhill—the area where Sherman watched Atlanta burn during the Civil War. Carter stated many times that his library could not be built without the expressway as access, which proved to be inaccurate. The only major national politician who strongly opposed the expressway and supported the neighborhoods was Congressman John Lewis. Local groups such as the Coalition against Unnecessary Thoroughfares in Older Neighborhoods Inc. (CAUTION) formed to formally oppose the highway in the court system. Other groups opposing the road were the Roadbusters and the *BOND Community Star* newspaper.

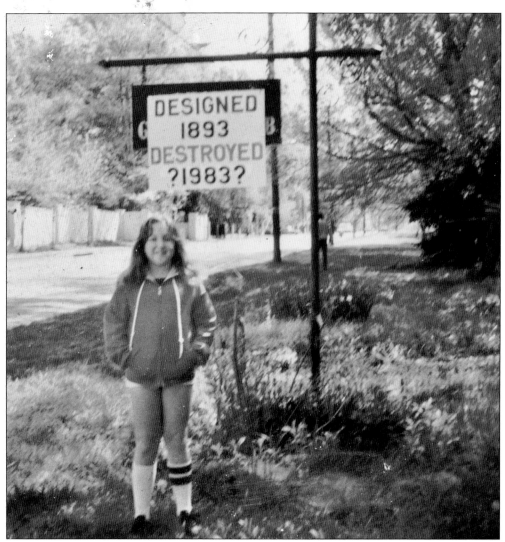

CHILDREN PROTEST THE ROAD. In-town neighborhoods went all-out to oppose the expressway. Groups such as CAUTION, The Druid Hills Civic Association, Candler Park Neighborhood Association, Lake Claire Neighbors, Inman Park Restoration, and the *BOND Community Star* fought the road. Other in-town civic and community organizations and the Roadbusters held protests, marched, and participated in acts of civil disobedience against the road. CAUTION raised and spent money on court cases seeking to halt the road. Massive protests were held at the opening of Carter's presidential library and other places such as city hall. Protesters came in all ages and colors, and children often joined their parents in protests. Young citizens such as Claudia Silverman (in mismatched socks) joined picket lines and protested the expressway. (Mary Alice Bray.)

Go Directly to Jail. Protesters who chained themselves to trees, sat under cranes or bulldozers, or climbed trees were arrested by Atlanta police and taken to jail. One protester was up in a tree when the tree was cut, and she crashed to the ground. Here, police drag away a protester who is practicing peaceful noncooperation. (Mary Alice Bray.)

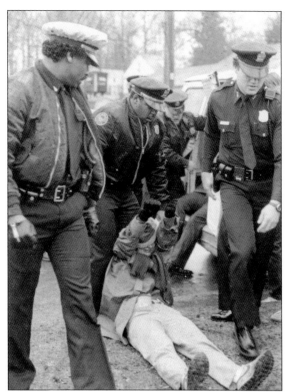

It's a Long Way to the Ground. Road construction entailed bringing in all sorts of heavy equipment. It was not unusual to see bulldozers in all sizes, ditch witches, tree-cutting equipment, and cranes in the neighborhood. Here, a Roadbusters protester has climbed high up on a crane, and a man is trying to make her get down. (Mary Alice Bray.)

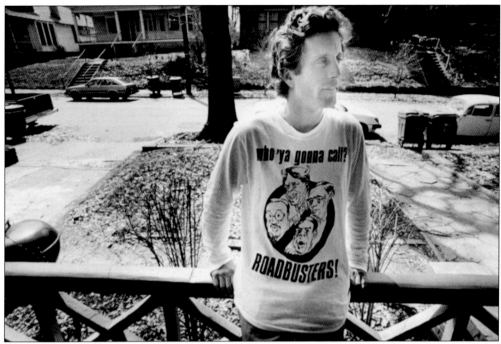

ROADBUSTERS. Danny Feig, an Inman Park resident and business owner, was one of the founders of the Roadbusters. He wears a Roadbuster T-shirt with caricatures of former president Jimmy Carter, former mayor Andrew Young, city council member Marvin Arrington, and GDOT chair Tom Moreland. These four men were seen as the most powerful proponents of the road. The Roadbusters practiced peaceful noncompliance with the expressway supporters and builders. (Mary Alice Bray.)

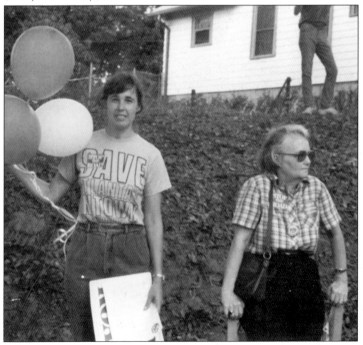

THE LOCAL PRESS TAKES ON JIMMY CARTER. Betty Knox (right) was a resident of Candler Park and a longtime organizer of distribution for the *BOND Community Star*, which served Inman Park, Little Five Points, Poncey Highland, Candler Park, and Lake Claire. Susan Hamilton (left) was the editor in chief of the *BOND Community Star*. Here, they head for a mass protest at the opening of the Jimmy Carter Presidential Library. (Mary Alice Bray.)

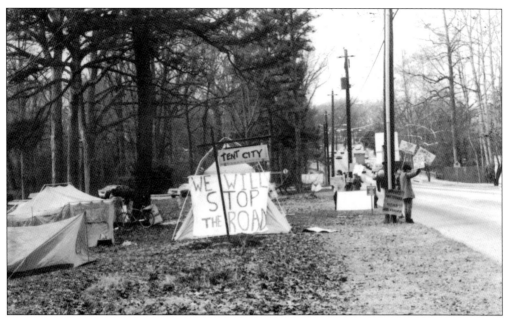

TENT CITY. Protesters erected a tent city in Shadyside Park right at the point where the proposed expressway would cross the park heading toward Ponce de Leon Avenue, which was to be significantly widened. Many protesters spent the night in the tents. Others walked along the old trolley right-of-way with picket signs. Still others marched downtown to city hall and to the Georgia State Capitol.

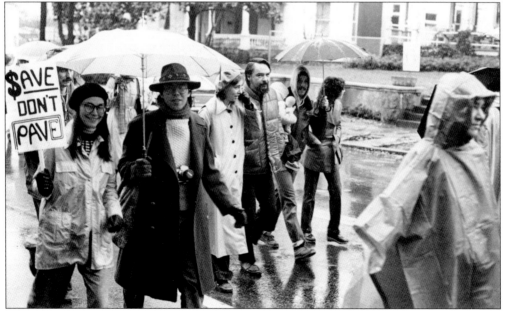

NEITHER RAIN, NOR SLEET, NOR SNOW . . . The protesters often faced obstacles other than the Georgia Department of Transportation, the expressway work crew, the police, jail, and city officials. But the protesters were diligent because they felt they had a noble fight on their hands to save their neighborhoods, trees, green space, and parks. Here, a peaceful protest march goes on despite a rainstorm. (Mary Alice Bray.)

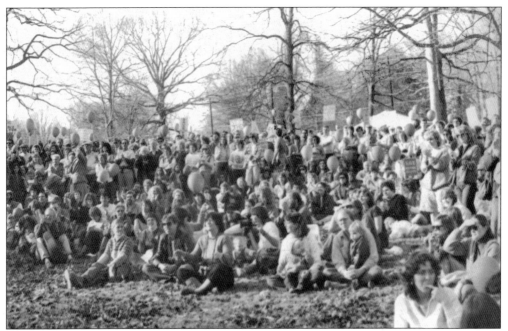

RALLIES. Rallies were held in different venues including Dellwood Park, where a huge crowd gathered to hear Rep. John Lewis speak. Lewis supported protesters against the road. That day, Lewis mesmerized the audience with his mellifluous, dynamic, and powerful speech. "This land is your land, this land is my land," he said. "This is not the land of Jimmy Carter, or Tom Moreland or Andrew Young. This land is your and my land!"

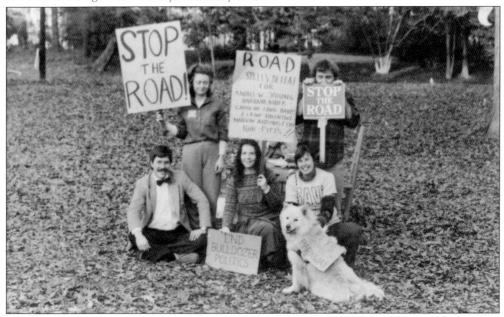

OTHER PROTESTS. Groups such as this one from the *BOND Community Star* set up smaller protests and handed out literature. From left to right are (first row) Wayne Richardson, Jennie Richardson, Panda the dog, and Susan Hamilton; (second row) Patricia Giblin and Woody Jones. Panda is wearing a "Pets against the Parkway" sign.

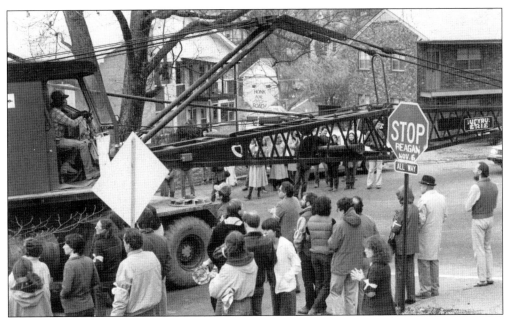

THE LONG AND WINDING ROAD. While CAUTION and other anti-road groups fought the expressway, the Georgia Department of Transportation continued with its plan to build the road. Bulldozers mowed down trees and shrubs, and houses were demolished. Land was graded. Giant concrete supports appeared where overpasses would be built. Protesters blocked the tree cutting and the bulldozers and cranes. (Mary Alice Bray.)

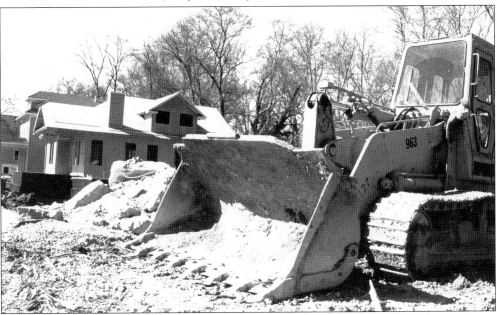

BULLDOZERS EVERYWHERE. During the road fight, it was not unusual to see all sorts of construction and destruction equipment in the neighborhoods. Bulldozers knocked down trees and shrubs and flattened the rolling terrain. They unleashed their power as they plunged into vacant houses taken by eminent domain. They splintered the timbers and pushed the bricks aside. Later, the wooden parts of former homes were fuel for bonfires spewing smoke. (Mary Alice Bray.)

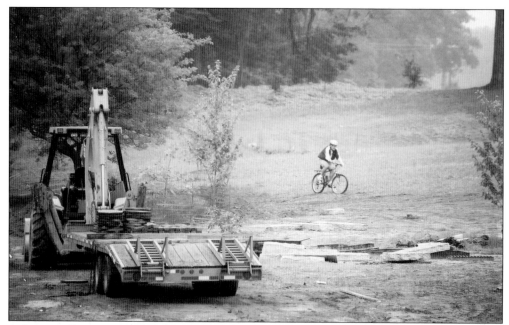

A STRANGE JUXTAPOSITION. What is out of place here? A cyclist sails along on what will eventually become a four-lane highway. Once paving was complete and the road was open to traffic, he would be taking his life in his hands sharing the road with automobiles. (Mary Alice Bray.)

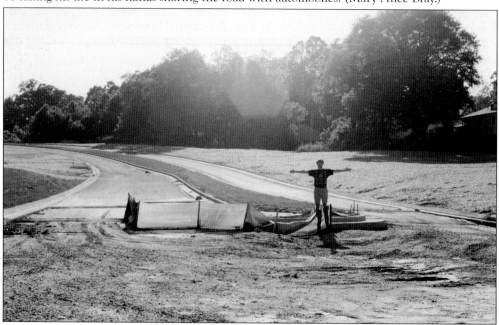

WHAT'S GOING TO HAPPEN? This man may wonder what is going to happen to the Presidential Parkway. Corruption was uncovered; the issue seemed stacked against the neighborhoods. Finally, Superior Court judge Clarence Seeliger ordered the parties into mediation. After lengthy negotiations, an agreement was reached. The road would dead end into Ponce de Leon Avenue west of the neighborhoods rather than going through them. The parts of the roads already built would be demolished. (Mary Alice Bray.)

HIGHWAYS 78 AND 29. This is a photograph of US 78 and 29 as they go through the small town of Snellville, Georgia. These are the same two highways that go through Druid Hills as Ponce de Leon Avenue. The road is clogged with traffic and lined with fast food restaurants. Perhaps this is what Ponce de Leon Avenue would have looked like if the Presidential Parkway had been constructed.

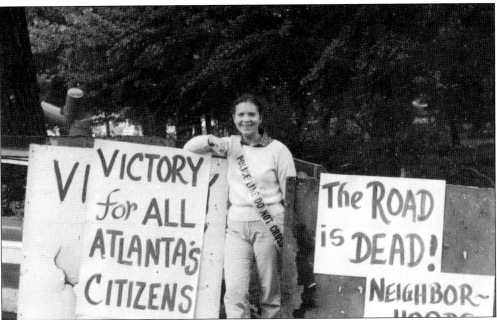

EXPRESSWAY? NO WAY! A powerful coalition of grassroots activism, peaceful noncooperation, organized legal and fund-raising groups to fight the issue in courts, and many years of work finally defeated the road. The Olmsted Linear Park and in-town neighborhoods were not destroyed by pavement. Jennie Richardson celebrates the victory.

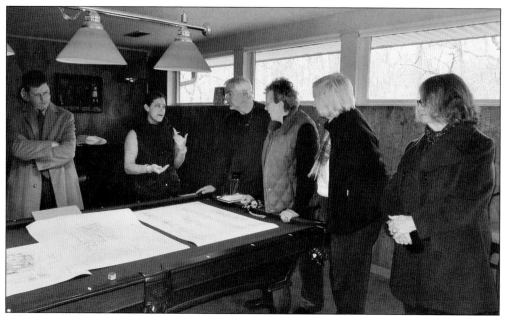

WHERE DO PRESERVATIONISTS TURN? The Druid Hills Landmark District Preservation Committee (LDPC) is the guardian of historic preservation for the park and the part of Druid Hills in Atlanta. It guides homeowners, architects, and contractors on what the district regulations allow and forbid. Here, the LDPC meets to go over plans. From left to right are Justin Critz, architect Lida Sease, LDPC chair Dan Frymire, Carol Sleeth, Alida Silverman, and Betsy Marvin.

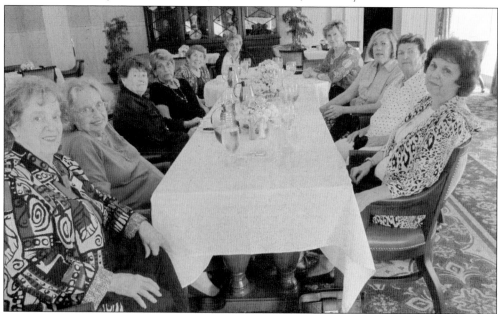

WHO PROTECTS HISTORIC STRUCTURES AND PARKS? One of the threats to the Olmsted Linear Park is lack of support for historic preservation on the part of national, state, and local governments. In addition to organized groups, grassroots groups and citizens have the duty to step in when historic structures and parks are jeopardized. The pictured women fought the road for decades, and the friendships formed continue to this day.

Six

REHABILITATION AND RENOVATION OF THE PARK

Dreams appear from out of a mist, rarely with a distinct beginning. They unwind their narrative thread and vanish with awakening. Parks seem to have a similar life cycle. Rarely do city residents know just when a park was born. It is just there—they are simply in it—it has just always been there, hasn't it? And when it is gone, it is gone for good, whispers of memory faintly recalled over coffee.

Well, no. Parks may emerge from the mists, but they are built by hard work, creativity, and patience. And they can and, sadly, do die. Like Humpty-Dumpty, the question remains: did he fall, or was he pushed? Sometimes the factors leading to the death or slow decline of a park are far from benign. Sometimes they are calculated with an expected result. Sometimes open space is viewed as a vacuum. Perhaps they are not abhorred, perhaps they are simply ignored and viewed as nothing special. An open space like a park with lots of room to simply live in is sometimes viewed as lacking in meaning until that space is filled with something. Such is a culture that values doing over being, a culture that cannot imagine a yogi, or anyone else, sitting still for long.

Sometimes, though, a hero emerges who has not been counted on. Such is the case with Druid Hills and the park at the center of the community. Once the hero emerged, the serious work began: how to breathe new life into a vision that is more compelling today than it was 129 years ago. What follows is that story.

A POWER COUPLE. The dream of restoring the Olmsted Linear Park began to take root in the early 1980s, prompted by the long threat of destruction by GDOT and informed by the enlightenment of Druid Hills resident Sally Harbaugh (left) through her association with the National Association of Olmsted Parks (NAOP). During Harbaugh's battles with GDOT, she found natural allies, and a whole world opened up to her: the world of Olmsted park champions who were rediscovering, renovating, restoring, and rehabilitating Olmsted parks in New York City, Buffalo, Seattle, Brooklyn, Boston, and elsewhere. Harbaugh's partner and longtime OLPA board chair was Tally Sweat (below), a woman of resolve with a seemingly infinite rolodex to corporate boards and a back channel to GDOT and Georgia Power. Tally's political know-how was essential for the success of the entire project.

OLMSTED SCHOLAR CHARLES BEVERIDGE PHD. Harbaugh's most important ally when she joined the board of NAOP in the early 1980s was Beveridge, who completed his dissertation on Olmsted at the University of Wisconsin in 1966, focusing on his work as a social reformer and writer. Beveridge also served as series editor for *The Papers of Frederick Law Olmsted*. The sesquicentennial of Olmsted's 1822 birth coincided with renewed interest in Olmsted parks nationwide; most cities of any size and importance were touched by Olmsted's direct work or work by his successor firms. Atlanta was no exception, though much of Olmsted's work here was met with frustration and projects that did not materialize. The work for the Kirkwood Land Development Company and Joel Hurt was the lucky exception. Druid Hills was Olmsted's last suburban development scheme. Beveridge was a consultant on each phase of the work on the linear park and was a vital part of the nationwide movement to recognize the genius of Olmsted as well as the genius loci of Druid Hills.

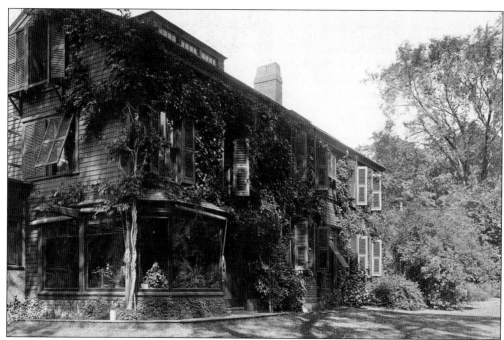

FAIRSTED, HOME TO OLMSTED ARCHIVES. For Harbaugh, a visit to Fairsted in Brookline, Massachusetts, was pivotal, as plans from the Olmsted firm's nearly 100-year history are housed there. Important proof of the elder Olsmted's active involvement in the design of the community was easy to find. "We simply have to have a master plan" was Sally Harbaugh's constant refrain through the road fight. As the fight was resolved, Harbaugh sought long-term protection and rehabilitation for the park. Through Park Pride, funds were secured to select a consultant and form the advisory committee around 1995. The winning firm was Altamira with Nicholas Quennell of Quennell-Rothchild. Town hall meetings were convened, and the 65-page master plan was completed and adopted by the Druid Hills Civic Association, presented to the Atlanta Urban Design Commission, and adopted by Atlanta and DeKalb County. Initial estimates for implementation were $10 million plus more for a maintenance endowment. Raising the funds became the focus of the newly formed Olmsted Linear Park Alliance. (Above, NPS Olmsted.)

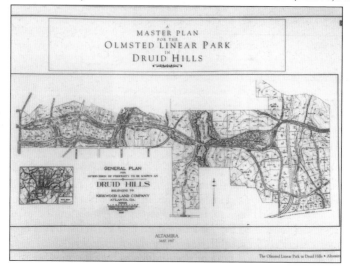

INITIAL PHASES OF WORK. OLPA defined a template to be used in subsequent phases of the rehabilitation. The five pastoral parks—with an open and gently rolling nature characterized by lawns, trees, and masses of flowering shrubs—constitute about 23 acres. Aspects common to all five are the demolition of nonoriginal features, pedestrian paths, planting consistent with Olmsted's conceptual planting or more detailed plans, utility burial, adding the City of Atlanta light standard adopted for the 1996 Olympic Games, planting street trees along Ponce de Leon Avenue, rehabilitating tired and beat-up turf, and installing a six-inch-high standard granite city curb. Work began in Oak Grove Park and continued with Virgilee, Shadyside, and Dellwood Parks. Springdale Park was the last to be tackled, as it offered its own difficulties in the necessary removal of an obsolete and unsafe playground. Curbs help protect the park from cars and trucks that take the word "park" quite literally.

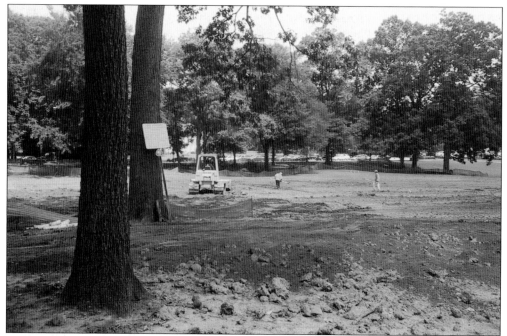

THE PASTORAL PARK. In the first five park segments, the land was already shaped gently from initial construction, so minimal grading was needed to accommodate a path that followed the lay of the land, generally less than five percent. Though gravel was considered, asphalt was used for the path system as compatible with macadam available in the 19th century.

CURVILINEAR FORMS. Due in part to the tools available during the period of construction and the horses and buggies still very much in use then, the grades for the pastoral parks are characteristically gentle and easily accommodate a variety of users. The curvilinear nature of the path system, paralleling that shown in the Olmsted Brothers illustrative graphic, responds readily to the landforms, caressed by the Olmsted touch.

ENTRAPMENT RISK! A wooden play structure was evaluated by a safety consultant who identified over 100 egregious safety code violations in his 40-page report. Entrapment risks and splinters were just a few of the highlights that could have led to severe injury or even death. The day after the report was presented to the parks department, the city condemned the play structure and began its demolition.

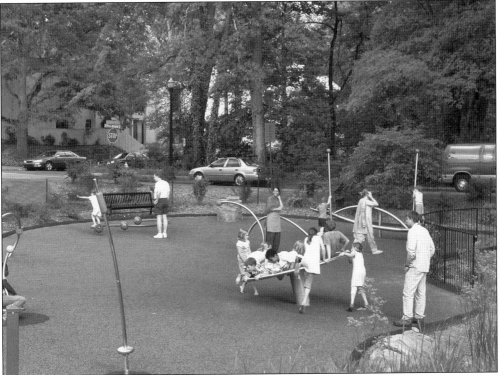

NEW PLAYGROUND. Tucked away out of the Olmstedian view corridor in an unobtrusive corner of Springdale Park, a new playground was added with safety surface and age-appropriate equipment. Olmsted accommodated many forms of active recreation in his parks but felt that unprogrammed open space was the most democratic—open to the interpretation of the greatest number of people and therefore of greater beauty and utility.

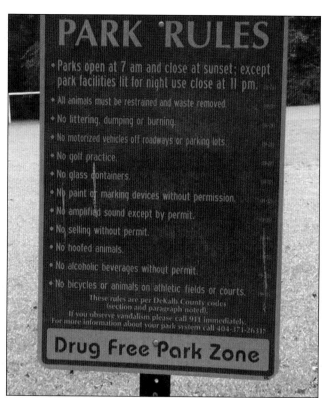

No Hooved Animals.
So reads the old rules sign posted by DeKalb County. It is not clear exactly why this prohibition was considered significant enough to post, though horses were kept on many properties within Druid Hills during the early years. This sign offers a picture of the low value this historic landscape was accorded even as highways were planned through this segment of the park.

Active Recreation Deserved Better. The sorry state of this soccer field in Deepdene Park, with its fixed goals, is an indication of the static nature of recreational planning during the 1950s and 1960s. This field, known now as the Mead, is in the east end of Deepdene and is more popular than ever.

AERIAL LITTER. Harbaugh often said somewhat wistfully, "We didn't think we'd ever get to Deepdene," so large did the undertaking appear. Deepdene Park took up four phases of its own: a demonstration area, the Vale and interior path system, signage and furnishings, and the Promenade and the Mead. Deepdene Park was the component of Olmsted's initial conceptual plan from 1892 that exhibited the least change over time in that he always intended it as a picturesque 22-acre forest reserve constituting slightly more than half the total park land. By far the most expensive component of this work was the burial of the utilities. When constructed, electricity was a novelty; not so at the turn of the 21st century. The overhead power lines required the shearing of the forest edge. During the replacement of natural gas lines and the installation of underground electrical cables and conduit, the original trolley tracks installed by Hurt were uncovered and a portion left as a reminder of this important element of Druid Hills and Atlanta history.

GRANITE CURBS PROTECT PARK LAND. One of the last remaining pieces of the master plan was the completion of the granite curb and attendant stormwater improvements along Ponce de Leon Avenue. In Phase I, granite curbing was installed along the south edge of all the pastoral parks, granite chosen as a more durable material than concrete curbs. Original stone gutters had been paved over, and without a functioning gutter or tactile warning at the edge of the roadway, cars were able to pull off South Ponce de Leon Avenue and park in each of the parks. With the conversion of houses into schools and churches, parking in parks was causing continued damage and leading to degradation of the parks with runoff, erosion, soil compaction, and tree loss. The degradation became a vicious spiral—the worse the park land looked, the worse it was treated, abuse begetting abuse. (Alida Silverman.)

Seven

A Walking Tour of the Neighborhood

The best way to see the Olmsted Linear Park is on foot. People in vehicles driving beside the park on either Big Ponce de Leon or Little Ponce de Leon Avenues might see a pleasing ribbon of green that appears between Moreland Avenue/Briarcliff Road and the CSX Railroad overpass, but that is like seeing a one-inch square of the *Mona Lisa* and thinking one has seen the entire painting. These park segments are paintings—though ones made by plant material instead of paints—and ones that keep changing according to season and light. By taking the time to walk, explore, and examine each nook and cranny of the park, one can get a feel for the true genius of Olmsted: whether it be sweeping vistas, thickly planted shrubs appearing to march together, or two proud oaks seeming to dance together. Closeups can be studies in the finer tendrils, thorns, and leaves of landscape plants; allowing vistas to lead one forward can be following the path Olmsted laid out.

Remember that these park segments were designed to be public. The open space was free to be enjoyed by the surrounding community, even though at the time, the South was still racially segregated. So sadly, the only African Americans who might be seen in the park in the beginning would be maids, domestic workers, and lawn workers awaiting the trolley. (Had Olmsted made the rules, the park would not have been racially segregated.) Asa Candler had wisely decided that, unlike most other projects in the Atlanta area, Druid Hills would not restrict Jewish citizens from residing there, and Candler's Druid Hills Corporation even voted to accept Jewish homeowners. As a result, many of the houses lining the linear park were inhabited by wealthy Jewish business owners, factory owners, lawyers, and physicians.

The five park segments with paved paths are suitable for strollers and wheelchairs; Deepdene is not. Bicycles and skateboards are discouraged.

Walkers can start their tour at either end of the linear park. This guide starts in Springdale, near the intersection of Briarcliff Road/Moreland Avenue and Ponce de Leon Avenue. To begin at the eastern end of the park, start with Deepdene and progress through the directions in reverse order.

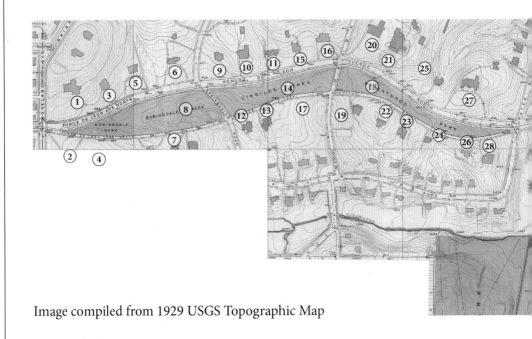

Image compiled from 1929 USGS Topographic Map

WALKING TOUR KEY

1. Judge Candler
2. McCord
3. Green Gables
4. Frank Lowenstein
5. BZ Phillips
6. Hirsh/Turner/Wein
7. Hare Krishna
8. Springdale Park
9. Warren Manor
10. Adair Estate
11. White Oaks
12. The Chimneys
13. Forrest Adair, Jr.
14. Virgilee Park
15. Champion/Jackson
16. Clyde King
17. Primitive Baptist
18. Oak Grove Park (Brightwood)
19. Paideia School
20. Stonehenge
21. Lemon Pie
22. Syda Foundation
23. The Mother Goose
24. Ponce de Leon Mews
25. Mormon Church
26. Max Lowenstein
27. The Villa
28. Davison/Harris

WALKING TOUR MAP. This map is from a 1928 USGS topographic series showing the houses then extant. The numbers in the descriptions on the following pages refer to the circled numbers seen here.

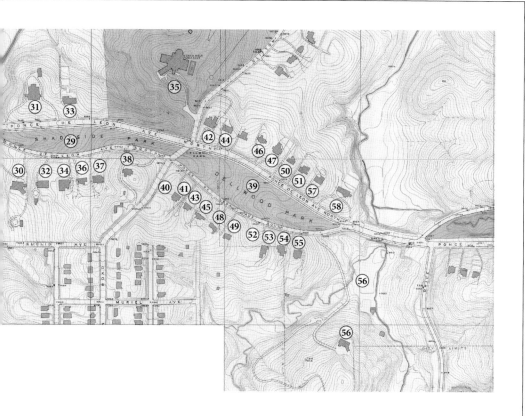

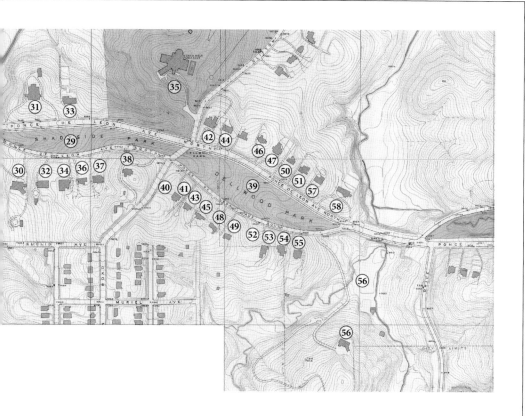

. Shadyside Park
. Pinebloom
. Rainbow Terrace
. Pattillo/Woolford
. Glenwoods
. Lloyd Preacher
. Druid Hills Golf Club
. Tudor Revival
. Dr. John Hurt
. El Paradisio
. Dellwood Park
. Smith House
. Alexander
. Twin Oaks
. Dellwood

44. Uhry
45. Yancey
46. Grady Lake
47. Frank S. Dean
48. Carmichael
49. Sally and Norman Harbaugh
50. McClatchey/OLPA
51. Willoughby
52. In-Fill Home
53. R.N. Fickett Home
54. Red Brick Georgian
55. Yellow Brick Foursquare
56. Cator Woolford
57. Coon Hollow
58. Asa Warren Candler, Jr.

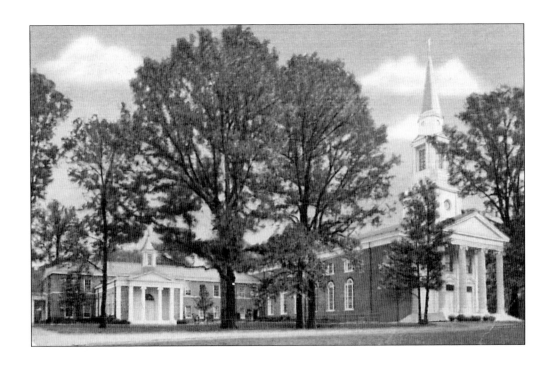

DRUID HILLS METHODIST AND JUDGE JOHN CANDLER'S HOUSE: No. 1. The redbrick former Druid Hills United Methodist Church is now a condominium community. The Georgian sanctuary was designed by Ivey and Crook around 1957. The church was built on the lot of the house of Judge John Candler—the first residence built in Druid Hills in 1909 and the first demolished.

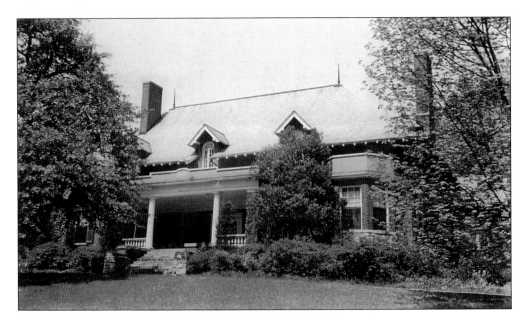

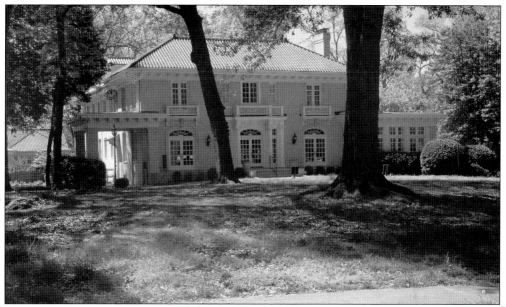

McCord House: No. 2. This Mediterranean home built for the Henry Y. McCord family was designed by DeFord Smith. McCord owned a wholesale grocery business. The house became the Fourth Church of Christ, Scientist, and was later the headquarters of Golden Key, a philanthropic organization. It was finally a real estate office and a law firm.

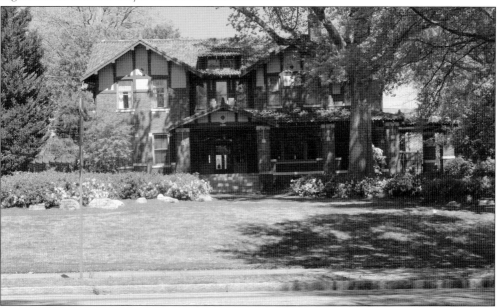

Green Gables: No. 3. Albert L. Dunn lived in this house and gave the Craftsman home its name. Dunn operated the Wonder Beverage Company, which distributed a nonalcoholic cereal-based drink called Bevo, advertised as being "irresistible, exhilarating, nourishing, pure and wholesome and an ideal drink for nursing mothers, invalids and old people." It was made by Anheuser-Busch. Before and after Prohibition, Dunn sold alcoholic beverages. Green Gables was built in 1910. The house later served as the parsonage of the Druid Hills Methodist Church, a daycare facility, and the Druid Hills church's community center. The house is now owned by a law firm.

FRANK LOWENSTEIN HOUSE: NO. 4. The Lowenstein house was built for one of three brothers who owned the Norris Candy Company. It was designed by Smith and Pringle in a Mediterranean style. The house was later the Unity Church, which added two nonhistoric wings. After Unity moved, the house was home to the Atlanta Boy Choir. Today, the In-Town Montessori School is on the site.

PHILLIPS HOUSE: NO. 5. This dwelling was built for attorney B.Z. Phillips and was designed by Neel Reid in 1913. Phillips was a prominent Jewish lawyer in Atlanta and in a practice with future governor John Slaton. His wife was Nettie Elsas Phillips of the Fulton Bag and Cotton Mill family and Cabbagetown fame. The Howard School for special needs students and the public Springdale Park Elementary School (City of Atlanta) later occupied the house.

HIRSCH/TURNER/WEIN HOUSE: NO. 6. The yellow-brick house was built on a lot sold to Henry Hirsch in 1923 for $30,000. The Hirsch family were great patrons of opera, and opera stars from the Met often gave concerts at the home. The house was designed by W.H. Nichols and Sons and completed in 1924. When Pres. Warren G. Harding came to Atlanta in 1931, he ate lunch at the Druid Hills Golf Club and later had tea with the Hirsches. The house became a boardinghouse and later was occupied by members of the Jim Wein family before being sold to Springdale Park Elementary School.

KRISHNAS: NO. 7. These three houses are owned by the International Society for Krishna Consciousness, which first rented and later purchased them in the 1970s. The houses were sold at a very favorable price due to their deterioration. Members of the group live in the homes, which are used for teaching, religious purposes, and banquets.

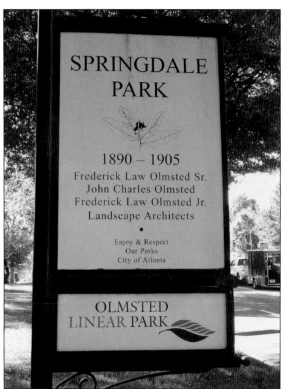

SPRINGDALE PARK: NO. 8. Springdale Road intersects the linear park at this point. Note that Springdale Road is slightly sunken below the grade of the park so that it almost disappears when viewing the long vista. Springdale Park is named for Silver Bell Spring, a natural spring that bubbles up near the northeast corner of the park. The granite bridge over a wetlands area was added when the park was rehabilitated.

WARREN MANOR: NO. 9. This house was built for George Warren in 1925 for $20,000. Warren, who owned a commercial refrigeration company, died in the mid-1930s, and his family continued to live there. The last owner before it became a part of the Adair Estate Condominiums was Juliette Dowling. She was one of several real estate speculators who purchased property near the park in hopes of building high-rises when the Stone Mountain Expressway was built.

ADAIR ESTATE: NO. 10. Forrest Adair was one of two brothers who owned the Adair Realty Company, official realtors of Druid Hills. Designed by Beverly and King of New York City in 1909–1910, the original home was over 15,000 square feet and surrounded by 15 acres of gardens and lawn and a swimming pool. The house changed hands several times and was run as a boardinghouse by the Clayton Johnsons. It was finally owned by Juliette Dowling, who lived in it during a time of substantial deterioration and squalor. One of the richest women in Atlanta, she specialized in buying deteriorating historic homes, allowing them to continue to degrade before selling them for demolition and development. The Warren Manor and the Adair home were sold to Historical Developments for repurposing as condominiums in the 1990s and later won an Urban Design Award for being the first sensitive repurposing project in Druid Hills. (Above, Alida Silverman.)

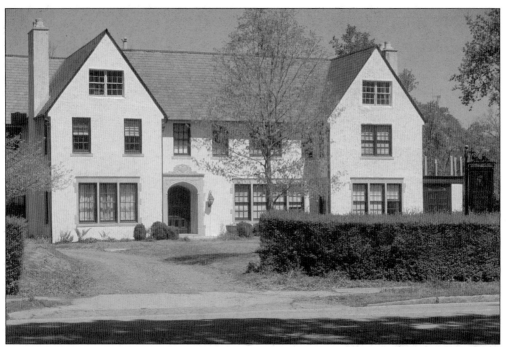

WHITE OAKS: NO. 11. Pringle and Smith designed this home, named for the trees surrounding it. It was built in 1923 for Robert H. White, an attorney, vice president and later president of the Atlanta Chamber of Commerce, and president of the Southern Wood Preserving Company.

THE CHIMNEYS: NO. 12. This 1970s community of condominiums was built of concrete in the mid-century modern style. In Druid Hills of the 1960s and 1970s, when historic homes deteriorated and were demolished, they were often replaced with ill-conforming condominiums or townhomes. The condominiums are individually owned and built around a paved courtyard.

FORREST ADAIR JR. HOUSE/ASHCRAFT HOUSE: NO. 13. This French chateau–style home was designed by Neel Reid (as job No. 286). Forrest Adair Jr. succeeded his father and uncle in operating the Adair Realty Company. The home was constructed in 1911 at a cost of $8,000. Today, it is part of the Paideia School.

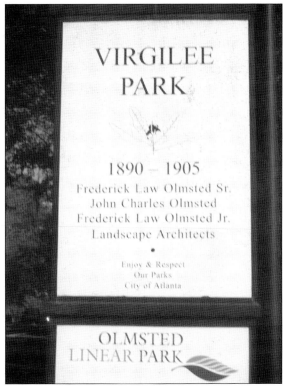

VIRGILEE PARK: NO. 14. Crossing over Springdale Road, walkers enter Virgilee Park. It is the only park segment to be named for a person (the rest are named for natural features). Virgilee, the young daughter of original Druid Hills developer Joel Hurt, died in 1884 just before her fourth birthday. She is buried at Atlanta's historic Oakland Cemetery downtown.

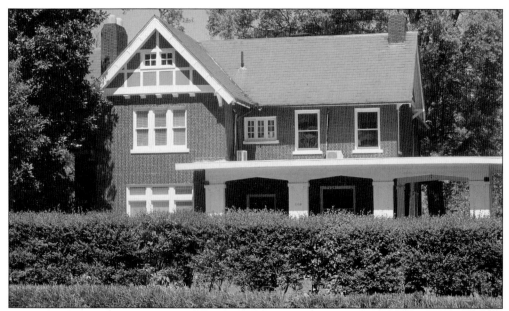

CHAMPION/JACKSON HOUSE: No. 15. Dr. William Leon Champion lived in the house and made medical house calls by horse and buggy. Dr. Champion was the first urologist to practice in Atlanta and was still practicing at the age of 83. Jim Jackson's family bought the home from Dr. Champion. Jackson's father owned a candy company, and his mother worked there adding red stripes to candy canes before she married Jim's father. Jim lived on Ponce de Leon Avenue until his death in 2019, when the home was sold to Paideia School.

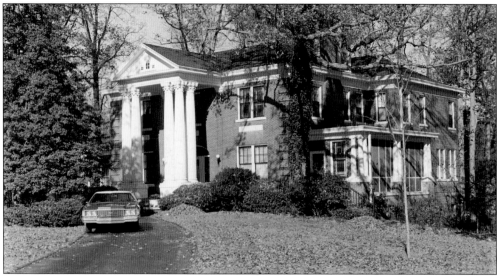

CLYDE KING HOUSE: No. 16. The King residence was first occupied in 1910. Clyde King was the founder and owner of the King Plow Company. Wachendorf Brothers designed the gardens, which contained plants and three connecting pools surrounded by low rock walls. King's daughter Irene married Robert Woodruff's brother George. Clara Bell King requested to be buried in the house's garden when she died, but the city did not allow it. Instead, she is at Oakland Cemetery with a monument that looks exactly like the facade of the house. Alpha Delta Pi Sorority purchased the home in 1954. The gardens were removed for an addition in the 1990s.

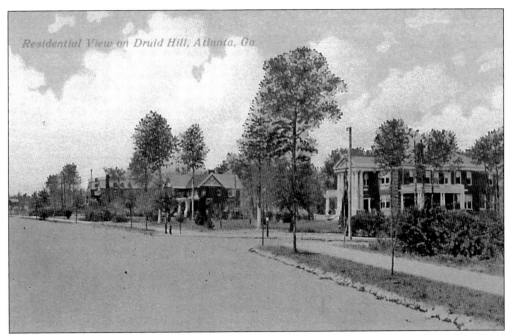

A View down Ponce de Leon Avenue. Looking west from the intersection of Oakdale Road and Ponce de Leon are the King house, the Champion/Jackson house, and in the distance, the Adair house (now the larger house at the Adair Estate). The image is taken from a tinted postcard published in the 1920s to advertise the beautiful houses of Druid Hills.

Church: No. 17. The Georgian-style redbrick Atlanta Primitive Baptist Church was built on a vacant lot in 1958. The church was founded in downtown Atlanta in 1922 and moved from Boulevard to the Druid Hills site after selling its previous property. The lot, purchased in 1954 for $8,800, had to be rezoned to allow the church to be constructed. The congregation is still active.

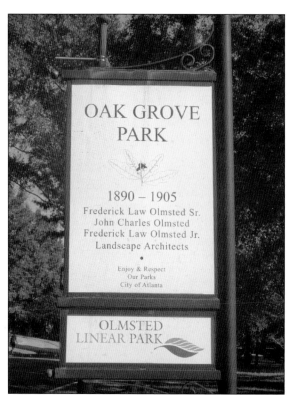

OAKDALE ROAD INTERSECTS AND THE BEGINNING OF OAK GROVE PARK: NO. 18. Because of the oaks planted on either side of Oakdale Road, many residents grew up calling the street the "Tree Tunnel." Oak Grove Park begins on the other side of Oakdale Road and is named for the grove of several varieties of oak trees.

PAIDEIA SCHOOL: NO. 19. The private, progressive Paideia School was founded in Druid Hills in 1971 in one derelict mansion, which was restored. As Paideia has grown, the school has purchased many more homes along the park, modifying some for use and demolishing noncontributing houses and rebuilding. One new building is the Paideia Middle School, which replaced Wimpole, Georgian-style redbrick condos built in the 1970s.

STONEHENGE: NO. 20. The Hoyt Venable house, Stonehenge, was built in 1914 of Stone Mountain granite and designed by Edward Emmett Dougherty in the Tudor Domestic Gothic style. Venable was one of the organizers of the revitalization of the KKK and helped organize the Confederate memorial carving on Stone Mountain. He also supported Klan meetings and cross burnings on top of the mountain. Stonehenge was purchased by the St. John Lutheran Church in 1959. The granite sanctuary was added in 1969 and was designed by Barker and Cunningham. The church is still active.

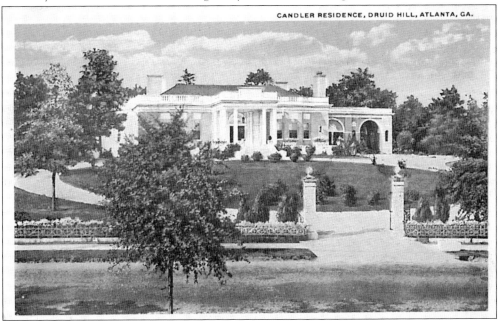

"LEMON PIE HOUSE:" NO. 21. The Asa Candler house is known as the "Lemon Pie House" by the family because of its yellow brick and white marble. It was Asa Sr. and Lucy's last home together. Built in 1915, it was Atlanta's costliest house at $210,000. It was designed by George Murphy, who also designed the Candler Building. The home was later used as headquarters for the American Legion before becoming the St. John Chrysostom Melkite Catholic Church. The church is still active today.

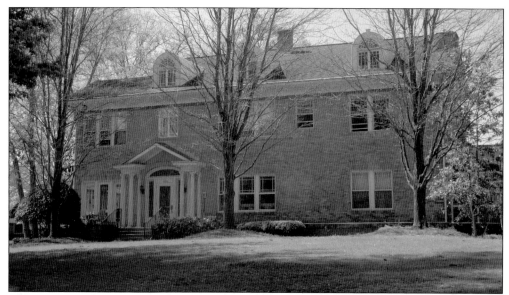

SYDA FOUNDATION: NO. 22. The yellow-brick Syda Foundation was the headquarters of the Siddha yoga group in Atlanta. The nonprofit organization was founded in 1974 to protect, preserve, and disseminate the Siddha yoga path. The group accomplished this by holding teachings, meditations, and rituals. The group sold the home to Paideia School and now has headquarters in another area of northeast Atlanta.

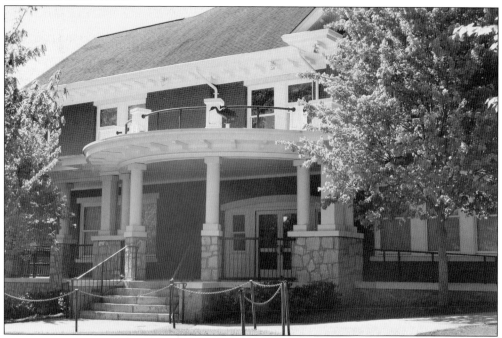

"MOTHER GOOSE HOUSE:" NO. 23. Lucy Candler and her husband, William Owens, lived in this house with their children Elizabeth and Bill Owens Jr. After her husband's death from the flu, Lucy moved back in with her parents. The house was later the Mother Goose Day Care Center before it was purchased by Paideia School. It burned in 2009 and was rebuilt exactly as it had been with the exception of a second floor, which was not original.

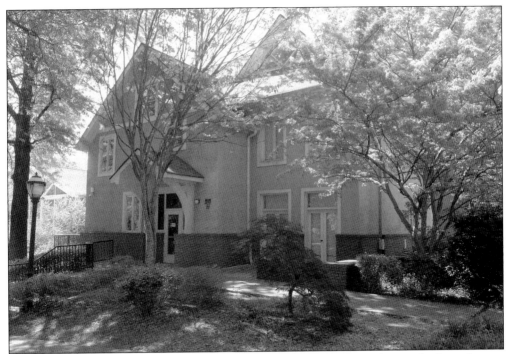

PONCE DE LEON MEWS: NO. 24. A mansion was turned into condos with more built on the rear of the property in the 1980s. Paideia School later bought the property and renovated it as part of the private school.

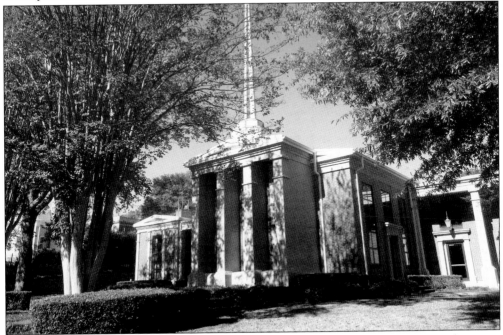

MORMON CHURCH: NO. 25. The Church of Jesus Christ of Latter-Day Saints is a mid-century modern redbrick church building. The Mormons meet here for their services and allow their parking lot to be used by Paideia students.

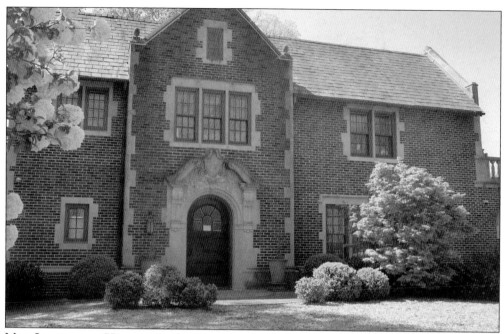

MAX LOWENSTEIN HOUSE: No. 26. The Max Lowenstein house was designed by Pringle and Smith in 1919–1920 with additions by the same firm in 1926. Max and his brother Frank ran the Norris Candy Company. The home was later purchased by Paideia School.

THE VILLA: No. 27. George Washington Adair Jr. and his brother Forrest ran the Adair Realty Company. Browne Decorating Company did all the interior work in the home. George was a mentor to Bobby Jones, and George's son Perry Adair was a fine golfer and friend of Jones. Adair was the second president of the Atlanta Athletic Club and helped found East Lake Golf Club. The Villa later became a boardinghouse for young businesswomen and was demolished in 1968. The Lion's Gate Condominiums now sit on its lot.

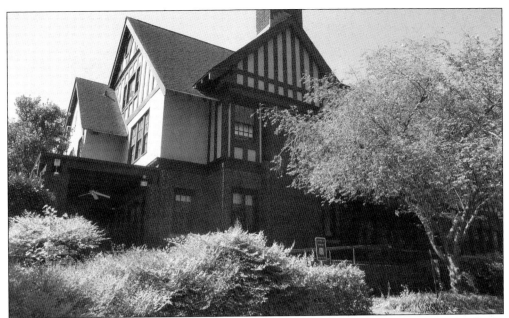

DAVISON/HARRIS HOUSE: NO. 28. Beaumont Davison, a partner in Davison's Department Store, built this home but soon sold it to Arthur Harris, president of the Atlanta Paper Company. The gardens in the rear were designed by Robert Cridland. They no longer exist. This was the first building purchased when Paideia School was founded.

CHILDREN IN THE GARDEN. Meredith Ogden Conklin and Hank Ogden scamper through the Cridland-designed boxwood garden behind the house of their grandparents Arthur and Irma Harris, while attentive mother Leila Harris Ogden provides a stabilizing influence. Robert Cridland was a Philadelphia landscape architect who designed more than five gardens in Atlanta between 1905 and 1920, including the Cator Woolford Garden, also on South Ponce de Leon Avenue, still intact. (Meredith Ogden Conklin.)

Lullwater Road Intersects: No. 29. Here Lullwater Creek passes under Ponce de Leon Avenue and the Shadyside Park segment begins. This was Olmsted's proposed site of Lullwater Lake. Hurt and Olmsted had a second bridge planned here, but a culvert was installed instead, causing flooding in part of Druid Hills.

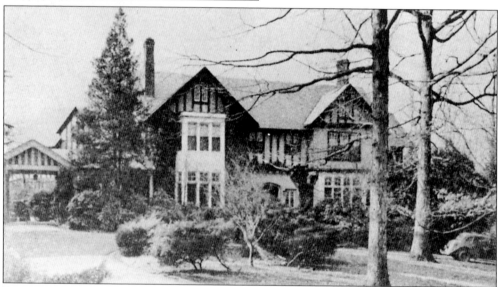

Pinebloom: No. 30. At the beginning of South Ponce de Leon Avenue is Preston Arkwright's estate. He was an attorney, president of Georgia Power and the Atlanta Street Railway Company, and one of the partners in the Druid Hills Corporation. After the deaths of the Arkwrights, the house was sold to the Baptist Radio Commission, which broadcast from the third floor. In the 1950s, the Jackson Hill Baptist Church purchased the property and constructed a large sanctuary. The church later donated the estate to the *Christian Index* with the stipulation that the church could continue to meet on the property. The Baptist Mission Board, which owned the *Index*, sold the property in 2021. The mansion will be divided into condos with more built around it. The sanctuary was demolished in July–August 2021.

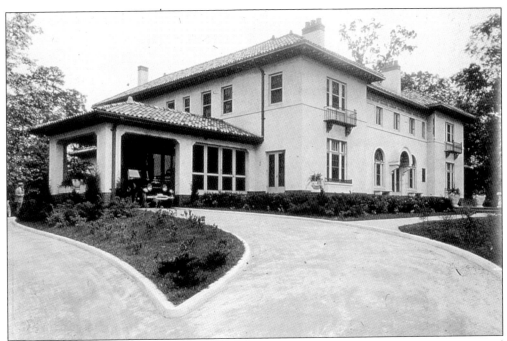

RAINBOW TERRACE: NO. 31. Rainbow Terrace was the mansion of Lucy Candler Heinz and her second husband, banker Henry Heinz. The house was designed by Lloyd Preacher in a Mediterranean Revival style. In 1943, Henry Heinz was killed by an intruder in the library of the house. Lucy never lived there again. It was abandoned and vandalized for years and considered haunted. The house was later purchased and rehabilitated as Lullwater Estate Condominiums, and other condos were built around the perimeter of the historic mansion. Below is the view from Rainbow Terrace toward Shadyside Park.

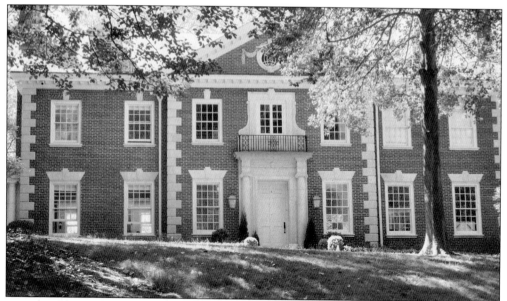

PATTILLO/WOOLFORD HOUSE: NO. 32. The house, designed by Pringle and Smith in the Georgian style, was built for the Pattillo family. However, they soon sold it to Guy Woolford, brother of Cator Woolford and cofounder of Retail Credit, which is now Equifax. Sitting on nearly two acres, the wooded lot had a boxwood garden, formal gardens, trails, and a fish pond. A foundation rented the home from Francis Woolford, and after her death, it was sold to a private resident. Today, the mansion has been cut into two condos with four freestanding houses in the rear yard.

GLENWOODS: NO. 33. Glenwoods was designed by Walter Downing in 1918 for J.G. "Buck" Dodson, who made his fortune from patent medicines. The house was gutted in 1933 and the interior redesigned by Philip Shutze. It sat on one acre, and nine additional acres consisted of gardens, a pond, stone bridges, a chapel, and mature boxwoods planted as mazes. The home was sold to a family in 1968, and the nine acres of gardens were razed to build the Dorchester Apartments, now Lullwater Parc Condominiums.

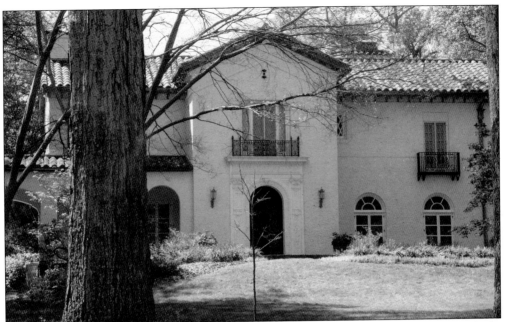

PREACHER FAMILY HOUSE: NO. 34. Architect Lloyd Preacher built this house for his family. Designed in a Mediterranean Revival style, the home features stained glass, beamed ceilings with hand-painted ornaments, and tiles. There is a trademark Preacher child's playhouse in the rear yard. The house was later used as the Dental Fraternity for Emory University. It has been lovingly restored by its current owners.

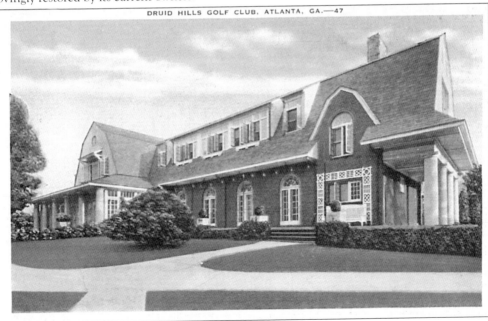

DRUID HILLS GOLF CLUB: NO. 35. The club was chartered in 1912 and the clubhouse designed by Edward Emmett Dougherty in 1913. The founders included Asa Candler, the Adair brothers, Preston Arkwright, and other notable Druid Hills citizens. The first president was H.M. Atkinson, president of Georgia Power, and the first winner of the club championship was a young Bobby Jones.

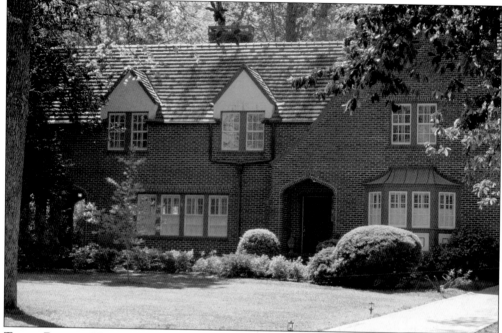

TUDOR REVIVAL HOUSE: NO. 36. This is likely a plan book home, as there is an exact copy of this house on Lullwater Road. The home was formerly owned by an Emory University professor and today remains privately owned.

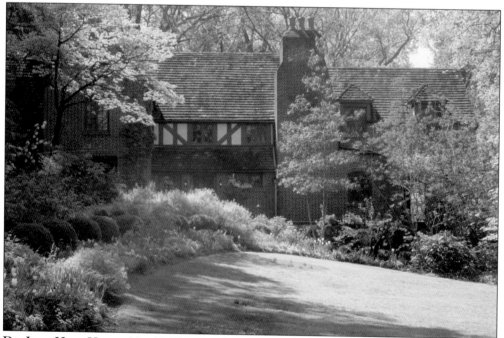

DR. JOHN HURT HOUSE: NO. 37. The Hurt house is next on the right. John was the brother of Joel Hurt. This sprawling redbrick home was said to be designed by Philip Shutze, but no evidence of that has been found. It was later purchased by Drs. Marion and Paul Kuntz, who were exceptional professors of Romance languages at Emory and Georgia State.

EL PARADISIO: NO. 38. This house was designed by Lewis Edmund Crook in 1923 in the Mediterranean style for the Fenn O. Stone family, and it sat on the highest point in Druid Hills. Crook's daughter said it was her father's favorite design. Fenn Stone owned the Stone Baking Company, which had bakeries in Cincinnati, Atlanta, and Texas and specialized in cakes. During construction, the Stones toured Italy to purchase furniture while a family of Italian artisans was brought over to construct all the plaster moldings and carvings inside the home. After Fenn Stone's death, the home changed hands several times, finally becoming the property of the Loeb family. Cordelia Loeb was the sister of Juliette Dowling. The plan was apparently to sell the property for high-rise development due to the prospect of the Stone Mountain Expressway being built. After Cordelia Loeb moved, the home was rented for decades then abandoned to deteriorate. It stood open, vacant, and vandalized while thieves removed everything of value. Finally, the home burned and was demolished by the city. The Paradiso townhomes occupy the spot today. The house is a textbook example of how Atlanta failed to protect one of its most historic and beautiful properties.

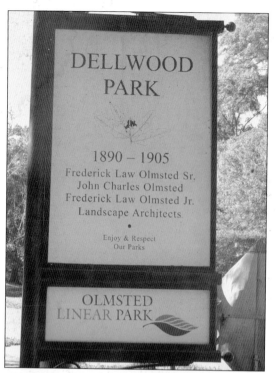

CLIFTON ROAD INTERSECTS: NO. 39. The original name of Clifton Road was Clifton Turnpike. Here is the beginning of Dellwood Park. "Dell" is an old English word for a bowl-shaped indentation. Standing slightly below the crest of the hill, one can easily look down to the east and see the dell. Along this park segment, much speculation of property took place in the 1970s, as Ponce de Leon Avenue was zoned for high-rises and an expressway was expected to be close by.

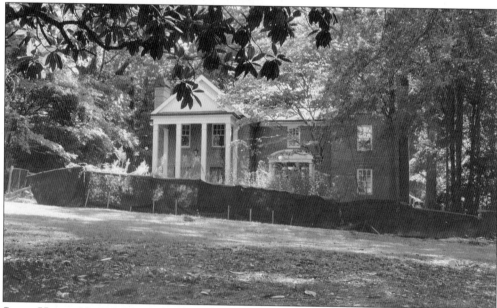

SMITH HOUSE: NO. 40. The former house of Rankin Smith's family is one of the only Antebellum Revival homes in Druid Hills. Rankin made his fortune with the Life Insurance Company of Georgia. In 1965, he paid $8.5 million for the Atlanta Falcons football team. He raised $43 million for Fernbank Museum, and the IMAX theater is named for him. His son Taylor sold the Falcons to Arthur Blank for $545 million in 2002. This house was used by several families and then burned twice, after which it was abandoned for over 40 years. This and the yellow foursquare house to the left (No. 41) are being renovated as a family compound.

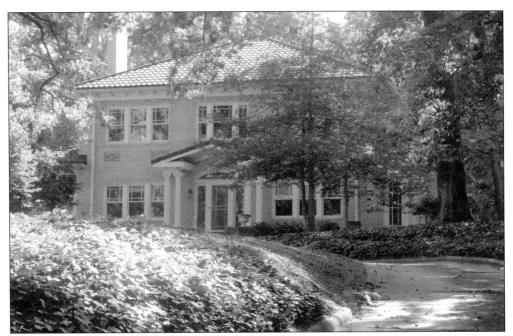

ALEXANDER HOUSE: NO. 41. The yellow foursquare is most likely a plan book house, since an identical house was built at the east end of the same block of South Ponce de Leon Avenue. John Alexander owned the home around 1916. It was later sold and the single-family house was divided into four apartments.

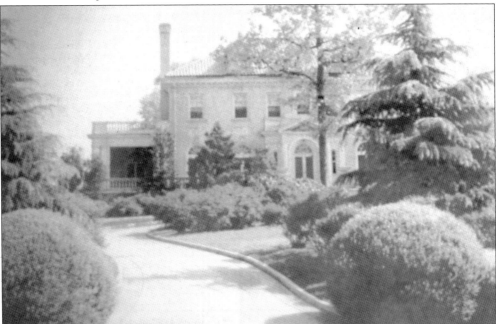

TWIN OAKS: NO. 42. Twin Oaks was named for the two oak trees in front. It was a yellow-brick Georgian-inspired home with gardens and tennis courts in the rear designed by DeFord Smith. It was built by George Willis. It was later sold to the Sewell family and was ultimately demolished by Fernbank in the 1980s.

DELLWOOD MANOR HOME: NO. 43. On the right is a Tudor Revival manor home. When Druid Hills was threatened by the expressway, the home was a boardinghouse, and it was later left open to deteriorate. It was to be demolished for a condominium community when purchased and saved by Dr. Janie Smith and Gary Smith, Esq.

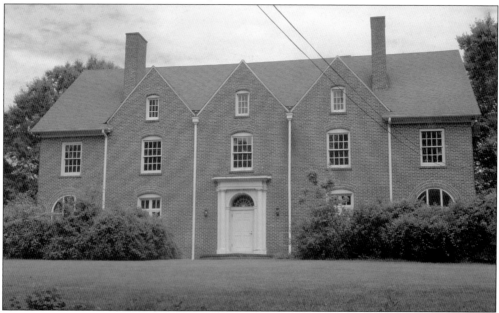

UHRY HOUSE: NO. 44. This home, made of red brick, was built for J.T. Holleman in 1916 and was designed by Rudolph Adler of Hentz, Reid & Adler. It was sold to Alfred Fox in 1941 and later to Alene Fox Uhry and Ralph K. Uhry. Playwright Alfred Uhry based one of the characters in his play *Driving Miss Daisy* on one of his relatives who lived in the house and another who lived nearby. The house is now owned by Fernbank.

LOOKING EAST FROM PONCE DE LEON AND CLIFTON ROAD. Twin Oaks and the Uhry home are seen in the 1920s. This was a tinted postcard used to advertise the splendor of the homes in Druid Hills.

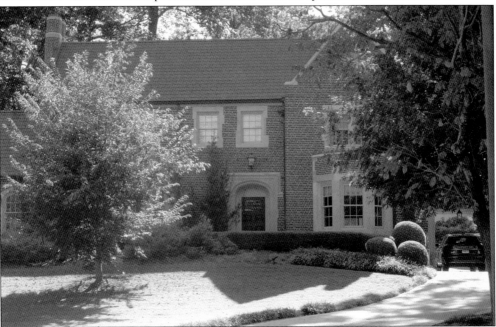

YANCEY HOUSE: NO. 45. This brick house in the style of an English manor was built in 1930 for B. Earle Yancey (1891–1960). He started Yancey Brothers and was the first dealer for the Adams Mule Grader, a machine that could do the work of eight mules. In 1918, he began selling Caterpillar tractors. In 2007, the company became an exclusive Blue Bird school bus dealer. The family continues to own and run the business to this day. The home fell into disrepair in the 1970s and was restored.

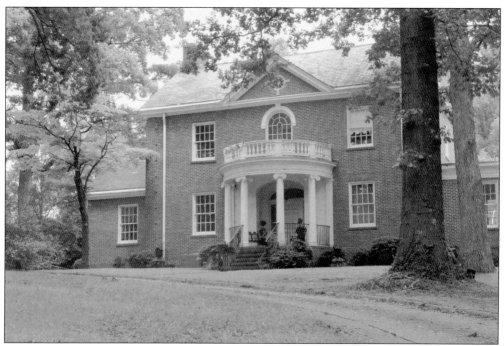

GRADY LAKE HOUSE: No. 46. This Ivey and Crook house was built in 1921 for Charles T. Nunnally and sold to Paul Fleming in 1923. In 1967, it was sold to Dr. Grady Lake, who was one of the first chiropractors in Atlanta. The Georgian-style redbrick home is single family.

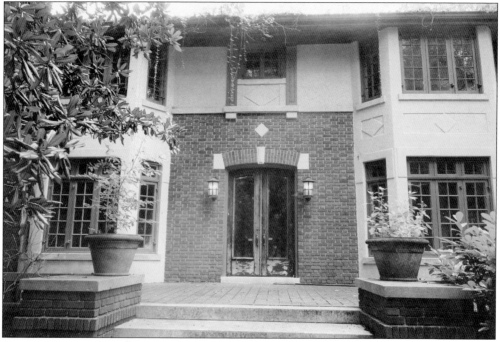

DEAN HOUSE: No. 47. The Prairie-style house was designed by Ten Eyck Brown for Frank S. Dean in 1912. In 1926, the house went to his wife, Maybell Dean, and it was sold to J.R. Hasty in 1947. Hasty broke the home into apartments. In 1983, he sold to Fernbank, which still owns the home.

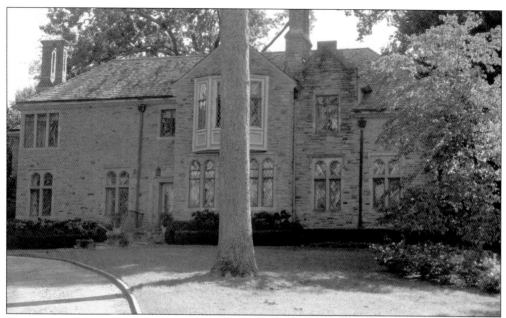

CARMICHAEL HOUSE: No. 48. The Carmichael family made paints, varnishes, and wallpaper. The home is made of solid stone with leaded-glass windows and elaborate millwork inside. Dr. Hentz Luten Teate, a noted pediatrician, later purchased the home. Jim Robertson, an Eastern pilot, owned the home for many years, and also owned a Mercedes that had been owned by Elvis Presley. The home remains single family.

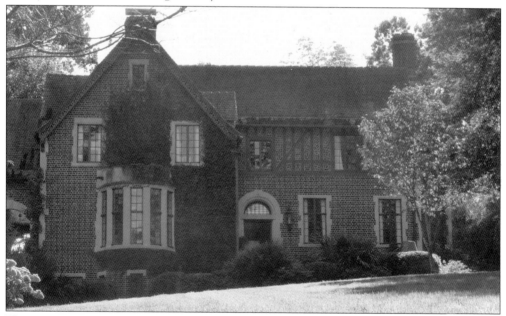

HARBAUGH HOUSE: No. 49. Owen Southwell designed this house in 1928. For many years, it was the home of Sally and Norman Harbaugh and the Olmsted Parks Society of Atlanta, which Sally founded. Sally did extensive research on the Olmsted park and Frederick Law Olmsted Sr. and was later instrumental in forming the Olmsted Linear Park Alliance, which renovated the park and brought Olmsted's name to the forefront. The house remains single family.

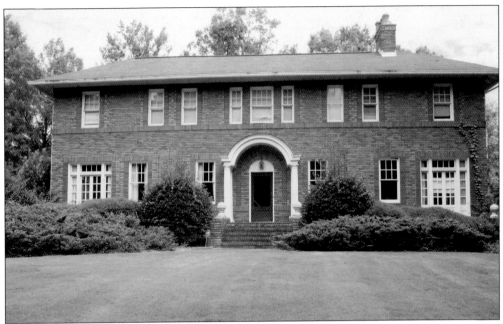

McClatchey House: No. 50. The yellow-brick McClatchey House was named after a prominent donor to Fernbank Museum. Several lawyers lived in the house at various times, including Hansell Granger and Hugh W. McWhorter. The house was used as a meeting spot for the Fernbank trustees and later became the headquarters of the OLPA.

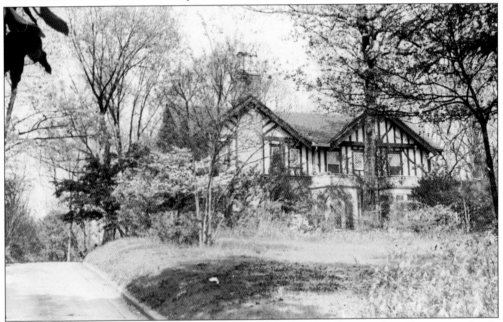

Willoughby House: No. 51. The Oliver Willoughby house once stood on this vacant lot. It was a large home built in the Tudor Revival style with a very deep backyard filled with trails and trees. The architect and year of construction are not known. Dr. Willoughby was a medical editor and writer. He later sold his home to Fernbank and moved to Clifton Terrace in the 1960s. The home was demolished by Fernbank.

INFILL HOUSE: NO. 52. This redbrick home has been renovated to become two stories after beginning as a one-story ranch home. It was an infill home, built on a vacant lot that had never been developed. It remains single family.

FOURSQUARE HOUSE: NO. 53. R.N. Fickett, who lived in this home, owned the largest broom and mop manufacturing plant in the United States. He was active in the Yaarab Temple and was chairman of the board of Baptist Tabernacle for 55 years. His wife was involved in many clubs and philanthropic organizations. An Atlanta elementary school is named for him.

BRICK GEORGIAN: NO. 54. At one point, this redbrick Georgian home was broken into apartments, but it is single family today. It changed hands several times and has been renovated.

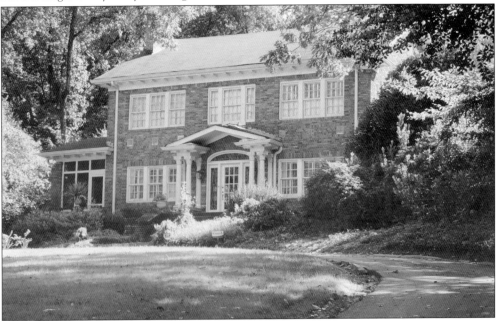

YELLOW-BRICK FOURSQUARE: NO. 55. This foursquare house is most likely a plan book home, as it is the same floorplan as the yellow-brick house at 1723 Ponce de Leon Avenue. It closely resembles several of the designs in the plan books of Atlanta architect Leila Ross Wilburn. One of the families that lived in the home converted the carriage house into a stable for their horses. Another family owned Colonial Foods, which became Big Star and later Publix. Today, it is a single-family home.

JACQUELAND: NO. 56. This is the house of Cator Woolford, cofounder of Retail Credit, which became Equifax. Woolford purchased the property behind the gates on the right as a hunting preserve. Most of the land was part of the General Gordon Estate, but the section closest to Ponce de Leon Avenue was part of Druid Hills. Two tributaries to Peavine Creek converge on the property. Woolford later hired Owen Southwell to design the Colonial Revival house on top of the hill. The grounds contained tennis courts, a nine-hole golf course, paths, ponds, greenhouses, and huge formal gardens designed by Robert Cridland. Today, the property is used by Cator Woolford Gardens.

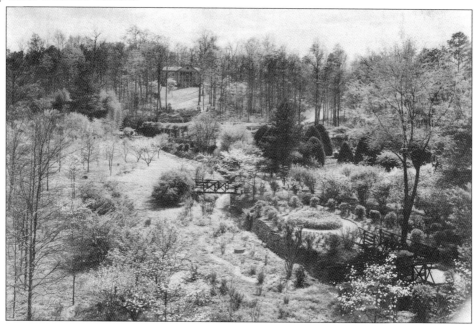

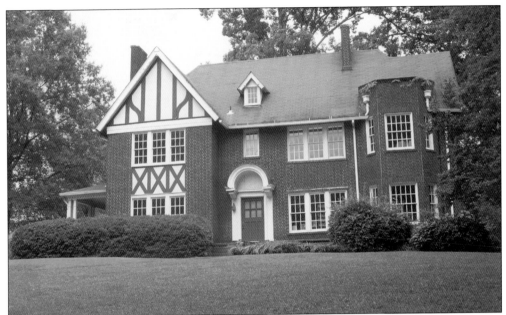

COON HOLLOW: NO. 57. The Tudor Revival house that belonged to Lorraine and Robert Cooney is known as Coon Hollow. Lorraine was editor of the important book *The Garden History of Georgia: 1733–1933*. The rear yard was extremely deep and contained a huge garden with meandering creeks, a formal area, a pond, and a replica of a Scottish chapel. The home is now owned by Fernbank.

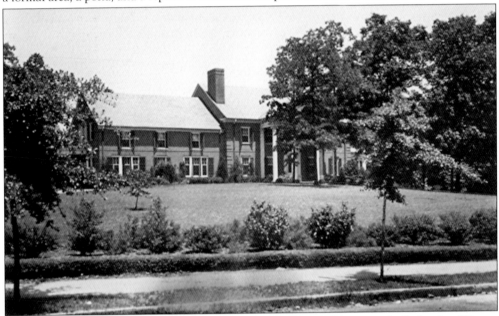

CANDLER HOUSE: NO. 58. This handsome redbrick Georgian home was built for Asa Warren Candler Jr. It was designed by Neel Reid in 1922 (as job No. 470). Behind the home are a carriage house/garage, fishpond, formal gardens, and informal wooded garden with native plants. After Candler died, his widow sold the house to the Catholic Church. A group of cloistered nuns moved into the home, which was then known as the Monastery of the Visitation. The nuns baked and sold bread for Communion to local Catholic parishes. Today, it is owned by Fernbank.

Eight

EPILOGUE

The park looks better than it has in 100 years. The vision of Hurt and Olmsted has been realized (though without the electric trolley for now): street trees are planted; greenswards are lush, green, and herbicide free; and shrub masses—deciduous, blooming, and evergreen—are modulating and subtly differentiating space, making the park seem larger than it is and furthering and thickening the veil between the traffic on Ponce de Leon Avenue and visitors in the park. Shrub masses filter the views of the cross streets so that from Springdale, the view to the east seems continuous across Virgilee and into Oak Grove.

Granite curbs along the bulk of Ponce de Leon Avenue protect the park from drivers who would otherwise find a convenient place to park on the lawns. Storm drainage has been improved, and a playground has been sited to maintain an open Olmstedian vista. The condition of Springdale, Virgilee, Oak Grove, Shadyside, and Dellwood is sound, and during the COVID-19 pandemic, they saw more visitors than in recent memory.

Deepdene Park, the 22-acre woodland, remains at risk. Despite the $1.5 million spent by OLPA, DeKalb County, and the Georgia Department of Transportation to build the Promenade along Ponce de Leon Avenue at Deepdene, current GDOT plans would demolish the pedestrian path, exhume carefully and expensively buried utilities, and cut down 61 twelve-inch tulip poplars to finally correct storm drainage along Ponce de Leon Avenue. Current GDOT engineers and leaders are planning to spend more public funds to demolish work completed between 2007 and 2011—work that was planned and coordinated with the combined efforts of OLPA consultants, GDOT engineers, and the leadership then in place.

GDOT has failed to maintain curb inlets on Ponce de Leon Avenue, which has led to extensive erosion within Deepdene and property owned by Fernbank, making it difficult for OLPA to complete its work to rehabilitate this forest preserve. Recent history has been forgotten or lost and mistakes repeated. Challenges remain, and a vigilant approach to the future is required.

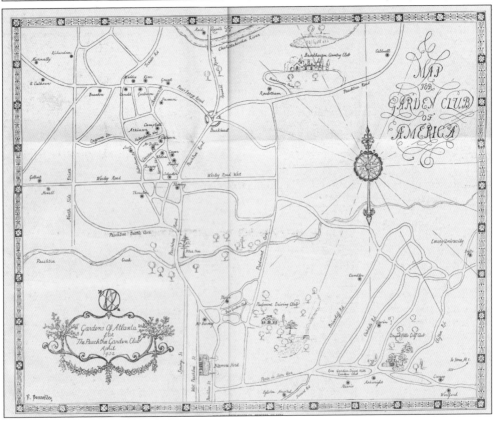

OLMSTED LEGACY NEARLY LOST. In a plaintive letter from Druid Hills and Ponce de Leon Avenue resident Lorraine Cooney to the Olmsted firm in 1931, she revealed her fervent wish that someone from the firm come to Atlanta and guide the rehabilitation of the park. Cooney was president of the Peachtree Garden Club, part of the Garden Club of America (GCA). She was the driving force and editor of the landmark book *Garden History of Georgia: 1733–1933.* The letter was written a year before the GCA held its annual meeting in Atlanta, but nothing seems to have come of Cooney's request. Even though eight gardens in Druid Hills were open to the 400 visiting GCA members, neither the program nor the promotional material sent to them mentioned that Druid Hills and its 45-acre linear park were designed by Olmsted, despite the fact the GCA membership was predominantly from the Northeast, an area rich with important Olmsted designs such as Manhattan's Central Park, Brooklyn's Prospect Park, and Boston's Emerald Necklace. (Left, LOC.)

HISTORY IS A TENUOUS THING. Less than 30 years after Druid Hills construction began, Olmsted's role in his last residential suburb had been forgotten. The Great Depression, World War II, and the ascendancy of modernism all played a part in this amnesia. In a touching letter from the mid-1930s, a Druid Hills resident praised the Georgia Highway Department for taking on the maintenance of Ponce de Leon Avenue. A generation later, the Georgia Department of Transportation and Atlanta Bureau of Planning had other ideas for what the future would bring. This new vision had nothing to do with the vision shared by Olmsted, Hurt, and Candler. Four narrow lanes of traffic were squeezed into what had been two generous lanes when the original functional gutters were paved over. The innovative electric trolley in the park became buses traveling on the street even while New Orleans retained its St. Charles line, and an expressway was planned that would have gutted the core of the neighborhood, literally paving the way for high-rises lining Ponce de Leon Avenue. (Below, Eric Halsey Williams.)

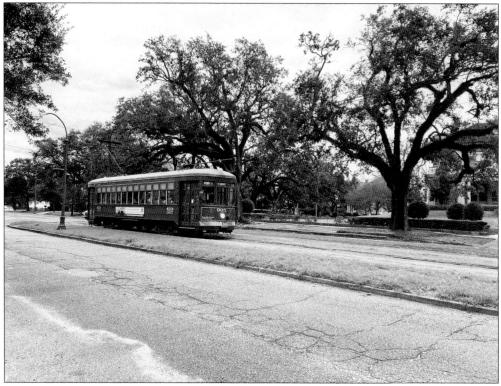

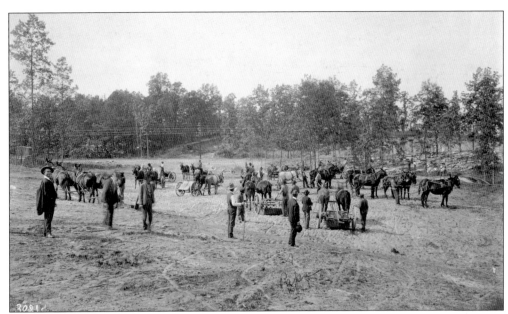

A HANDMADE LANDSCAPE. Handmade is what any landscape begun in the early 20th century truly was, as there was no other way to build. These are fragile places. Road gradients, critical to an Olmsted design, were gentle because they were shaped by drag pans and mules, shown at work in nearby Ansley Park, designed by one of Druid Hills' civil engineers, S.Z. Ruff. Horses had to traverse these roads pulling carriages and drays. Roads followed the lay of the land for beauty, and for economy as well. Drastic changes in the land cost the developer money. Building in a floodplain was considered dumb, and builders knew why it was best to build on high ground. Olmsted provided an attractive alternative to Hurt that was a win-win: build on the high ground and turn the lower-lying ground to advantage as open space. Current building techniques, powered by enormous machines, make the lay of the land an afterthought. As the prophet Isaiah said: "Every valley shall be exalted, every mountain and hill shall be made low." (Above, AHC.)

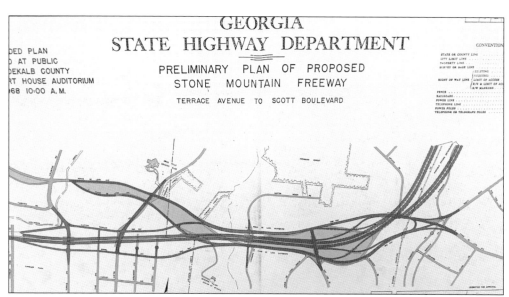

GEORGIA
STATE HIGHWAY DEPARTMENT

PRELIMINARY PLAN OF PROPOSED
STONE MOUNTAIN FREEWAY

TERRACE AVENUE TO SCOTT BOULEVARD

DED PLAN
D AT PUBLIC
DEKALB COUNTY
RT HOUSE AUDITORIUM
168 10:00 A.M.

CONVENTION

WE'RE GOING TO BE SO MODERN. A famous Savannahian criticism of Atlanta's bluster was: "If Atlanta could draw as hard as it blows, it would be a seaport." Part of the growing energy of Atlanta's drive to be the capital of the Southeastern United States was the construction of an interstate highway system rivaled by none. Olmsted and Hurt's inclusive vision of roads and an electric trolley was abandoned. The 22-acre woodland at Deepdene, a constant in all of the Olmsted designs for Druid Hills, would have been a casualty. The highway movement's basic assumption, based on continued residential flight from the city center with businesses remaining behind, would crumble by the early 21st century. Every model for urbanization has been challenged in recent years by changes in technology and society to such an extent that in May 2020, one could safely lie down in Ponce de Leon Avenue at 6:00 p.m. on a Friday night. Is past prologue? Could an electric trolley return to the park again? (Below, Followill.)

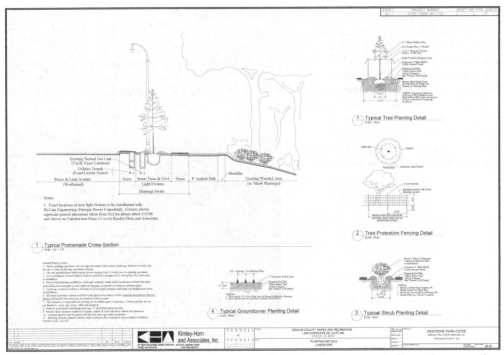

COMPLICATED PERMITTING. Getting work permitted in Deepdene was a challenge because of its stream. The work to bury utilities, construct paths, and plant trees—completed along the Promenade in 2011—was expensive and required coordination and cooperation with GDOT as well as their approval. Contemporaneously, GDOT developed plans to add functional curbs, stormwater inlets, and piping along Ponce de Leon Avenue in a similar spirit of cooperation. These plans were set aside. All the while, the simple replacement and routine maintenance of curb inlets on Ponce was ignored and has caused considerable erosion downstream. When planning resumed in 2017, the prior cooperative plan all had agreed upon was deemed insufficient and all the prior work would be demolished. OLPA made an enormous commitment of funds and was betrayed by a bureaucracy not known for its responsibility for impact. Can OLPA be made whole in these negotiations so that its work to rehabilitate a nationally important historic landscape may continue?

The Kingdom Was Lost for Want of a Nail? There is no such thing as benign neglect; it is the very definition of erosive. GDOT maintenance failures have led to erosion in Deepdene, Fernbank, and every downstream neighbor bordering the creek. What GDOT does with stormwater has a huge ripple effect. The best place to address erosion is at the top of a watershed, as seen here.

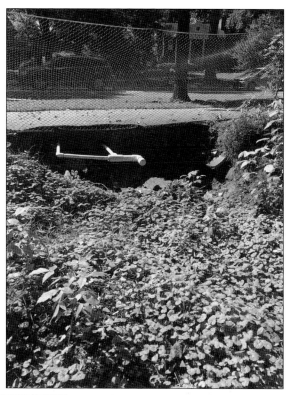

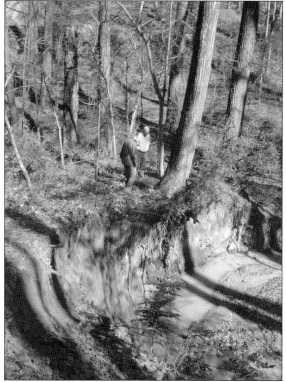

If a Tree Falls in the Forest? A management and maintenance plan for the linear park is needed with a specific focus on forested, picturesque Deepdene. Some events can be foreseen without a crystal ball. Olmsted used technology as a tool to further beauty, not as beauty's master. Continue the work in Deepdene in a manner consistent with Olmsted's principles.

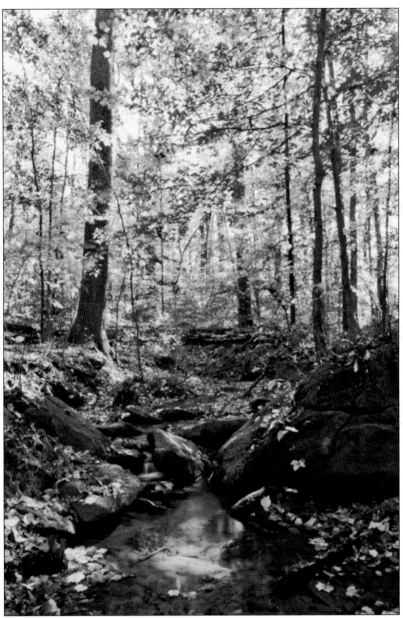

THERE IS WORK TO BE DONE. Sally Harbaugh, the spiritual soul of the park's rehabilitation, had moments of doubt and of misty gratitude. "We didn't think we'd ever get to Deepdene," since its problems of invasive plants, stormwater management, and creek erosion were so daunting. This work to heal this picturesque landscape, so valued by Olmsted that he identified in his first plans as a place for preservation, was put on hold while a resolution can be reached with the powers that be. Is there enough accomplished to let Harbaugh or Olmsted rest easy? Enough has been done to show the way forward, but it will require vigilance on the part of future OLPA boards and residents to ensure that the all-important consent decree that constrains GDOT's actions is honored. Deepdene is a part of a 100-acre forest system that includes Fernbank and Cator Woolford Gardens. These three forests share a common heritage and are natural allies that can work together with other stakeholders to accomplish their different but similar missions. (OLPA.)

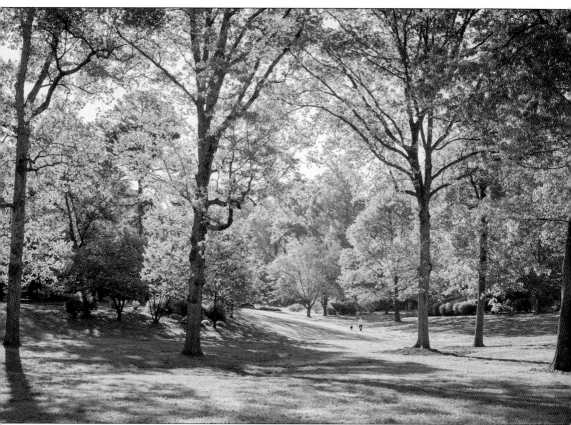

THE STRIFE IS O'ER, THE BATTLE DONE? The land Olmsted and Hurt set aside for parks and open space means more today than it has at any time since the development of Druid Hills. How to keep the vision alive? A published and agreed roadmap is needed for the maintenance of the parks. The alliance between the City of Atlanta, DeKalb County, and Fernbank needs to be fostered and maintained, for the park serves this community, city, and culturally, the region and country. An understanding of the significance of this work must be maintained along with the parkland itself. This park lies within Olmsted's last residential suburb and so occupies an important place in the Olmsted oeuvre. OLPA must maintain a strong alliance with partners, stakeholders, and other Olmsted places across the country that share similar obstacles and opportunities to bolster the work being done here. This is a living landscape that has accommodated profound change since construction and will need to respond to changes to come. (Followill.)

Discover Thousands of Local History Books
Featuring Millions of Vintage Images

Arcadia Publishing, the leading local history publisher in the United States, is committed to making history accessible and meaningful through publishing books that celebrate and preserve the heritage of America's people and places.

Find more books like this at
www.arcadiapublishing.com

Search for your hometown history, your old stomping grounds, and even your favorite sports team.